IMAGES
of America

DENTON

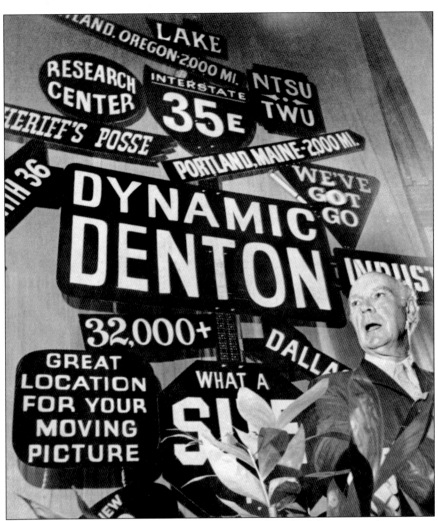

DYNAMIC DENTON. The Denton Chamber of Commerce described the city in a long-range image-building campaign from 1967–1971 as "Dynamic Denton." A record album, *Denton, Texas: In Sound and Music*, cut in 1967, touted the city's attributes as "a city . . . where education, research, and culture and entertainment rival the offerings of cities four times her size . . . a city with a dynamic and progressive spirit that long ago said 'No' to status quo . . . and 'Yes' to status 'GO'." A movie, *Dynamic Denton*, with the album sound track, followed in 1968 featuring a cast of six young Dentonites including Phyllis George. The campaign ended with a promotional trip to New York where the current Miss America, Phyllis George, spoke about the qualities of her hometown. (*Denton Record-Chronicle*.)

ON THE COVER: DENTON BOOSTERS. During World War II, local businessmen worked on farms through the efforts of the agricultural bureau of the Denton Chamber of Commerce, which was assisting farmers in their problem of labor shortage. In June 1943, local merchant Will Williams, pictured here in the left front seat, took a group of men, including Lee Preston, Milton Penry, Emory Taylor, Ed Miller, Robert B. Neale Jr., and Otis Fowler, to chop cotton on the D. M. Barber farm east of Denton. (*Denton Record-Chronicle*.)

IMAGES
of America

DENTON

Georgia Caraway and Kim Cupit

ARCADIA
PUBLISHING

Copyright © 2009 by Georgia Caraway and Kim Cupit
ISBN 978-0-7385-7854-5

Published by Arcadia Publishing
Charleston SC, Chicago IL, Portsmouth NH, San Francisco CA

Printed in the United States of America

Library of Congress Control Number: 2009928046

For all general information contact Arcadia Publishing at:
Telephone 843-853-2070
Fax 843-853-0044
E-mail sales@arcadiapublishing.com
For customer service and orders:
Toll-Free 1-888-313-2665

Visit us on the Internet at www.arcadiapublishing.com

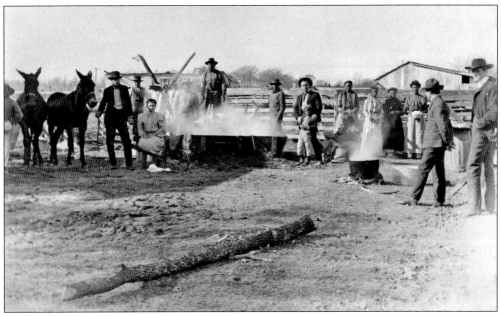

HOG KILLIN' TIME. This photograph was taken at the Pitner slaughtering and processing site located on land with plentiful trees near Newton Street. Free-range hogs lived in the woods scavenging acorns and other food. The time of year to butcher hogs depended on the weather; it had to be cold enough to keep meat from spoiling, but warm enough to keep the carcasses from freezing. Butchering day began before daylight by starting a fire under the scalding barrel and under an iron kettle. The scalding barrel had to be large enough to hold an entire hog. The kettle was used to keep fresh hot water to replenish what boiled away in the barrel and to heat water to clean. Doc and Marjorie Pitner later sold the land to the school district for Tomas Rivera Elementary School. (Denton County Museums.)

CONTENTS

ACKNOWLEDGMENTS

The authors wish to thank the following for helping us while we were compiling and writing this book: members of the Denton County Historical Commission and the Denton County Commissioners Court for their unwavering support; Martha Len Nelson, who proofread the manuscript using her unsurpassed knowledge of Denton history; the *Denton Record-Chronicle* newspaper for donating their photographic archive to the Denton County Museums; the Denton Public Library genealogy staff (especially Leslie, Kathy, and Laura); the University of North Texas Archives and History Portal; the University of North Texas Press, and Texas Woman's University Archives staff (Kimberly and Dawn).

Thank you Richard Harris, Bill Gentry, Celia and Mike Reid, Paul Voertman, Iris Ramey, the Independent Order of Odd Fellows, Kay Williams Goodman, the family of V. C. Adams, Kim Smith, Abigail Miller, Verda Piott, Gloria Anderson, Rod Fleming, Jovita Ramirez, Erma Peace, and Virgil and Gayle Strange for loaning photographs. Patsy Anderson donated to the museum a phenomenal collection of slides her father, R. P. Shannon, took during the Denton Centennial and Eisenhower's visit.

We also want to recognize the donations of photographs from the estates of Doc and Marjorie Pitner and Willie Lee Taylor.

We consulted the research materials, books, and articles by Mike Cochran, Michele Glaze, Bullitt Lowry, Dale Odom, Sylvia Barlow Greenwood, Edna McCormick, Ed F. Bates, C. A. Bridges, Keith Shelton, James L. Rogers, Richard Himmel, Bob La Forte, Phyllis Bridges, Joyce Thompson, Nita Thurman, Lila Knight, and various Denton churches.

The staff of Arcadia Publishing was wonderful to work with and made the process fun, particularly Luke Cunningham and Hannah Carney.

Special acknowledgment goes to the staff of the Denton County Museums, Robyn Lee for her editing skills, Roslyn Shelton who kept the office and museums functioning while we worked on this book, and especially Kate Lynass for driving all over Denton retrieving photographs and research materials and interviewing contributors.

We want to dedicate this book to family and friends who sustained us during the two hectic months of writing. And to Lilly, who reminds us of our future as we study our past. You are all in our hearts.

The images in this volume appear courtesy of the Denton County Museums (DCM), the Denton Public Library (DPL), the University of North Texas Archives and History Portal and University of North Texas Press (UNT), Texas Woman's University Archives (TWU), and the *Denton Record-Chronicle* archives (DRC), which are now part of the Denton County Museums' archive.

INTRODUCTION

Denton is indeed a dynamic city, from the downtown square—which has conducted business for more than 150 years—to the excellent educational institutions and energetic and progressive citizens of the city; Denton has its own sense of place in Texas.

On April 11, 1846, Denton County was among 31 new counties created by the Texas Legislature. The county was named for John B. Denton, a pioneer preacher and lawyer who died in an Indian battle in 1841.

The first county seat was Pinckneyville. The county seat moved in 1848 to an area 3 miles southeast named Alton, which is now the present town of Corinth. Due to a lack of water, the county seat moved again to Hickory Creek. This site was also called Alton. In 1856, residents wanted a more centrally located county seat. Hiram Cisco, William Loving, and William Woodruff donated a 100-acre tract on Pecan Creek. They named this new city Denton.

Otis G. Welch, as lawyer, with Charles Lacy and William Woodruff, as surveyors, platted the city and named the streets after trees in the county. Sheriff Charles Alexander Williams auctioned the lots on January 10, 1857, and construction began on the new town square. Johnny Lovejoy and Henderson Murphy moved their store and hotel from Alton to the south side of the square along Hickory Street. The first structure built on the square was James Smoot's general merchandise store on the west side along Elm Street, followed by the law office of Otis G. Welch on the east side along Locust Street. A log courthouse was erected facing Oak Street on the north side of the square. The city was chartered in 1866 and the first mayor was J. B. Sawyer in 1869.

Until the late 1870s, the structures were primarily made of wood, making them susceptible to fire. In 1860, fire destroyed the entire west side, including James Smoot's store. The courthouse burned on Christmas Eve in 1875, and a new brick courthouse was built in the center of the square the following year. Businesses on the south side of the square burned in 1877, and the Lacy Hotel burned in 1884. The fire department was formed in 1874 as a volunteer bucket brigade.

In addition to the 1876 courthouse, several new brick buildings were constructed in the 1870s, including the Piner Block on the south side and the Paschall Building on the east side. The Paschall Building, constructed in 1877 and located at 122 North Locust Street, is one of the oldest buildings on the square.

During Denton's early years, agriculture and livestock influenced the economy of Denton County. Cattle and horses became increasingly important; however, subsistence farming remained the primary way of life during this time. Due to the lack of transportation for bringing goods to the city, early settlers became self-sufficient.

By the 1880s, Denton truly became the center of the county. The Texas and Pacific Railroad and Missouri–Kansas–Texas Railroad arrived in 1881. A major shift occurred from subsistence farming to cash crops such as cotton, wheat, and corn. The Deavenport Mill and the Farmers Alliance Mill were established to accommodate the increase in crop production.

Municipal buildings were constructed near the downtown square to house city services such as fire, law enforcement, postal, power, telephone, and government offices. Other developments during the 1880s included the first financial institutions. The population of Denton more than doubled between 1880 and 1890 as a result of the railroad. After 1900, the automobile replaced horse and buggies, and the need for sufficient roads became imperative.

Education has always been important to the growth of the city. In the 1890s, the "Syndicate," the predecessor to the Denton Chamber of Commerce, realized the need for economic growth. This organization secured the first college in Denton, now known as the University of North Texas, thus establishing the town as an educational center for North Texas. Denton was selected over 14 other cities, due to a donation of 67 acres of land, for what is now Texas Woman's University. The first classes were held in the fall of 1903. The Denton Independent School District experienced exponential growth and maintained a standard of excellence.

The African American community of Quakertown, established in the 1880s, was comprised of 60 families and several businesses and churches. Many of the residents worked at the nearby colleges as cooks, janitors, pantry men, stablemen, and groundskeepers. Women took in laundry and worked as housekeepers for wealthy white residents. Angeline Burr, a laundress and popular midwife, was one of the first people to purchase land in Quakertown. Henry Taylor, known for his gardening skills, maintained his yard like it was a park with a rare white lilac bush and a magnificent elm tree. Without consideration of Quakertown residents, the city purchased the land in 1922 to create the first Denton city park. The community was moved to Solomon Hill in southeast Denton. Some Quakertown residents chose to leave town and others moved their houses to the new area. Ross and Maude Hembry moved several houses from Quakertown to Solomon Hill and provided rental homes for displaced residents.

In the 1920s, Denton promoted itself as the "Ideal Home City." The city prepared for an expanding population by paving streets, building new schools, constructing a new city hall, and installing electric streetlights.

Dentonites served their country in all branches of the armed forces. On the home front, the city provided support for war times by training pilots at local airfields. After World War II, the population increased more than 90 percent and the economy shifted from agricultural to industrial. Denton finally developed an industrial base with manufacturing plants, an airport, and a public hospital. In 1959, the new city charter called for a council and city manager form of government.

By the late 1950s, Denton outgrew the city's original 100 acres. When U.S. Interstate-Highway 35 was constructed, the city was chosen to be the home of a Nike missile base, the Denton State School, and a Federal Emergency Management Agency regional center.

The citizens of Denton remain proud of their heritage. From the commemoration of its 100th anniversary as a city in 1957 to the continuous celebration of its history through the Courthouse-on-the-Square Museum and the Historical Park of Denton County, Denton remains the dynamic city at the top of the Dallas/Fort Worth Metroplex Golden Triangle.

One

THE DOWNTOWN SQUARE
THE HEART OF THE CITY

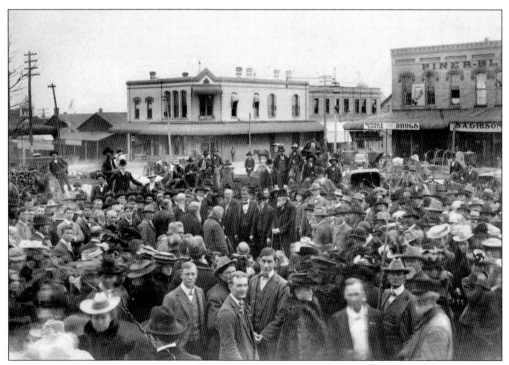

JOHN B. DENTON BURIAL. Capt. John B. Denton was mortally wounded May 24, 1841 during a militia raid on an Indian village east of Fort Worth. He was buried near a creek in Denton County. In 1856, John Chisum discovered Denton's body and reburied his remains on his Bolivar ranch. On November 21, 1901, the Old Settlers' Association reinterred Denton's remains on the courthouse lawn. Pallbearers were E. B. Orr, L. Willis, J. M. Swisher, John W. Gober, John H. Hawkins, and William C. Wright. (DPL.)

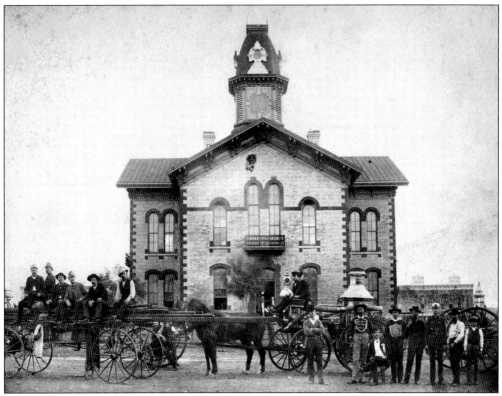

Second Courthouse on the Square, 1876. The first Denton courthouse was built on the north side of the square in 1857. It burned down on December 24, 1875. The second courthouse opened in 1877, was condemned as unsafe in 1894, and was struck by lightning. It was demolished in 1895 and broken bricks were used to pave North Elm Street. William C. Wright purchased the whole bricks to build the Wright Opera House. (DCM.)

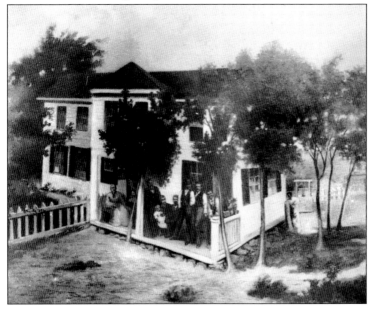

The Lacy House Hotel. Sarah Lacy, Charles C. Lacy's wife, ran the Lacy House on the northeast side of the public square from 1858 until it burned in 1884. The imposing wooden structure with a wagon yard and stables was painted white and had a well, which was said to be capable of watering 5,900 head of stock at one time. Louis Eyth painted this depiction of the Lacy family on the hotel porch. (DCM.)

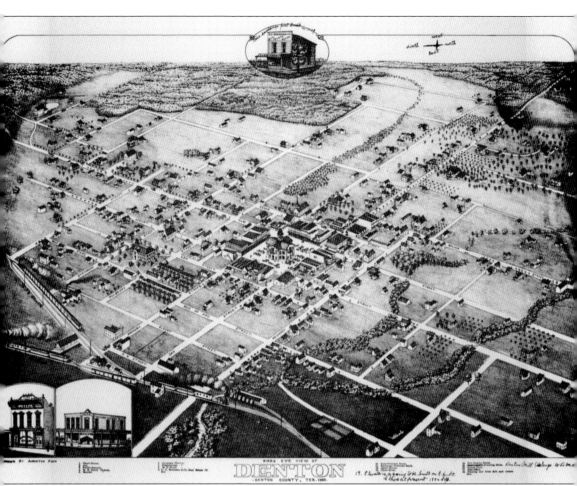

BIRD'S-EYE VIEW OF DENTON, TEXAS. Augustus Koch drew this bird's-eye view of Denton in 1883, depicting development around the courthouse square, with additional commercial development along secondary streets. This is the earliest known map to show the 1876 courthouse in the center of the square. Public schools, churches, banks, an opera house, hotels, a firehouse, flour mills, a cotton gin and yard, a post office, a grist mill, and the newly laid railroad tracks are all shown. By the 1880s, some of the finest homes were built along Oak Street. (DCM.)

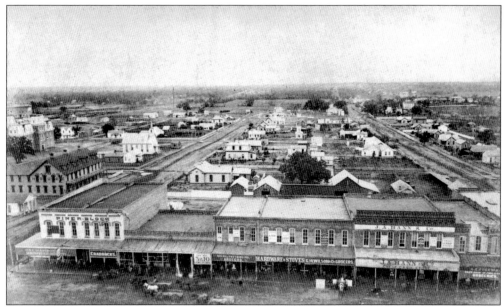

SOUTH SIDE OF THE SQUARE, C. 1889. A fire destroyed the south side of the square in 1877. By the end of the 1880s, businesses facing Hickory Street were rebuilt to include Search Hardware, Craddock Saloon, Evers Hardware, G. W. Wilson Grocery, J. A. Hann Dry Goods, Thompson Saloon, and Baldwin's Drug Store. On the left are the Oatman House, the public school, and the Methodist church. (DPL.)

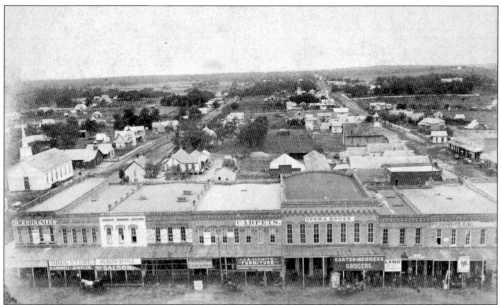

WEST SIDE OF THE SQUARE, C. 1889. The west side experienced two devastating fires in 1860 and 1994. This photograph shows the Elm Street businesses that were constructed on the square over the next 20 years, including Lipscomb's Drug Store, Houston Stiff Saloon, the *Denton Chronicle* office, Cleveland Groceries, J. B. Schmitz Furniture, the opera house, Carter and Benners Grocery, Ben Key's Tin Shop, C. F. Sanders and Company Saddles and Harness, and Scripture Grocery. (DCM.)

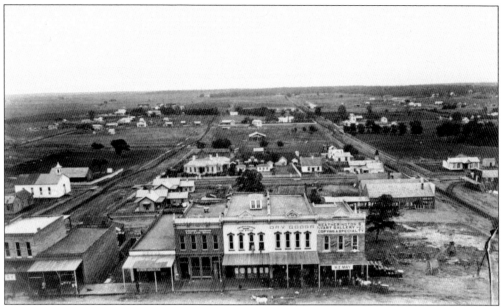

NORTH SIDE OF THE SQUARE, C. 1889. These buildings were constructed in the 1880s on Oak Street and many stand today. The vacant lot is where the Lacy House stood. The businesses included Fred and Charles Mentzen Bakery, Dave Fry's Meat Market, First National Bank, Ferguson and Davidson Real Estate, Emory C. Smith's Law Office, W. J. McNeil and Son Dry Goods, and the Weatherington Art Gallery. (DPL.)

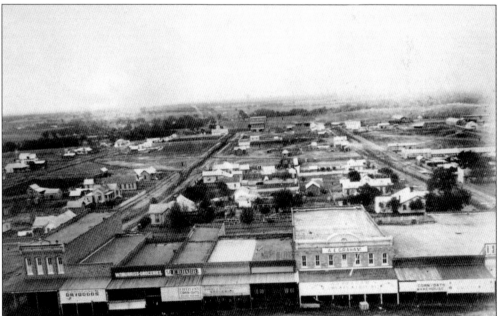

EAST SIDE OF THE SQUARE, C. 1889. Businesses operating in the 1880s on Locust Street were R. S. Ross Drug Store in the Paschall Building, C. A. Williams Dry Goods, William Burris Grocery, Fritzlen Feed and Livery, Jones and Williston Grocery, A. E. Graham Dry Goods, Hearn and Company Dry Goods, and Wells and Collins Saloon. On July 15, 1890, a fire destroyed the entire east side except for the Paschall Building, which stands today. (DCM.)

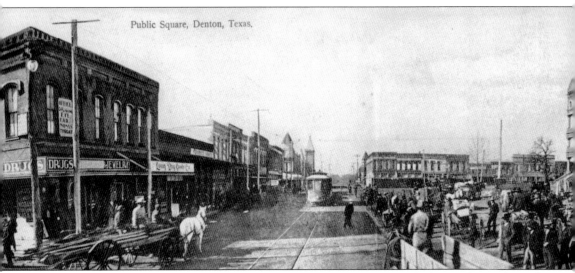

Public Square, Denton, Texas.

PANORAMA OF DENTON SQUARE. This real photograph postcard, postmarked 1909, shows Elm and Locust Streets taken from Hickory Street on the public square on a busy market day. The square was the gathering place for commerce and trade. The trolley traveling south on Elm Street took

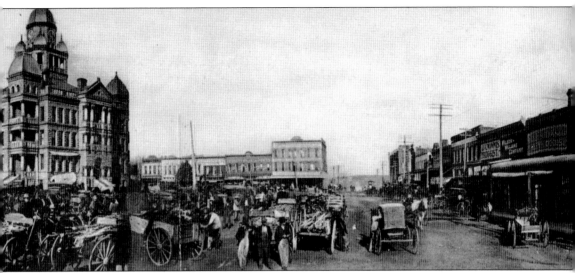

passengers from the direction of the College of Industrial Arts. In the background (on the right) are the May Building and the Wright Opera House. The Christian Church spire and the tower of the first location for the Taylor Hardware store are in the background on the left. (DCM.)

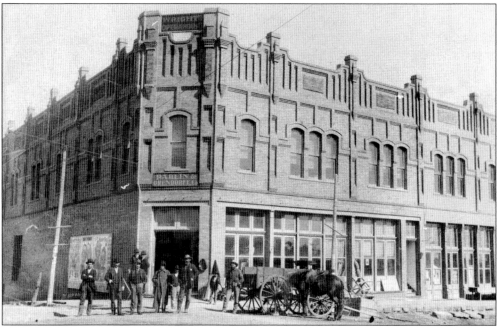

WRIGHT OPERA HOUSE. William Crow Wright built his opera house on the northeast corner of the square for $25,000. After the opera house opening on February 14, 1900, it became one of the centers of Denton's social scene. The facility seated 750–1,000 people at a ticket price ranging from 10¢ to 35¢. Parlin and Orendorff Implement Company occupied the first floor. The entertainment center closed in 1913 with the advent of movies. (DPL.)

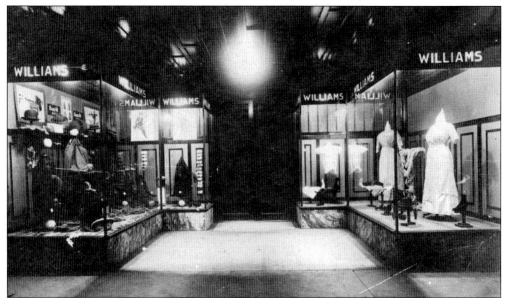

THE WILLIAMS STORE. After several partnerships and moves dating from 1857, C. Alex Williams opened a dry goods store adjoining the Paschall Building on Locust Street in 1884. When the 1890 fire destroyed this building, Williams moved his store further down Locust Street next to the Denton County National Bank. Management of the store passed to Will Williams upon his father's death. The store was sold in 1956. (DPL.)

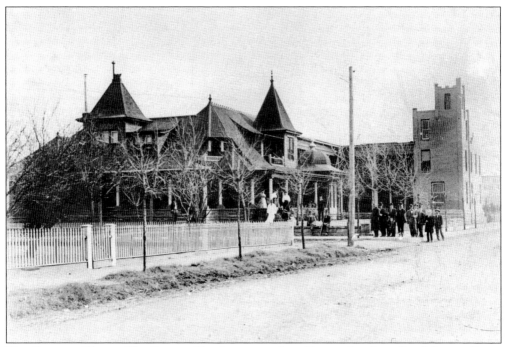

THE COTTAGE HOTEL. The Cottage Hotel was one of two Denton hotels on South Locust Street providing daily transportation from the city's train depot. The original hotel burned in 1909. The hotel's successor—with the same name—met a similar fate in 1927. (DPL.)

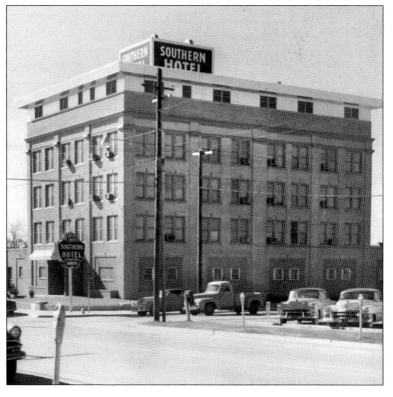

THE SOUTHERN HOTEL. In June 1927, Claude Godwin opened the 60-room Godwin Hotel at 300 South Locust Street. The Rayzor brothers purchased the building in 1931. The building operated as the Southern Hotel until February 24, 1960. After that time, it was leased to Texas Woman's University for a graduate residence hall. Currently the site serves as low-income elderly housing. (DRC.)

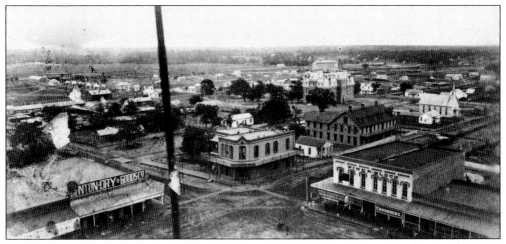

SOUTHEAST CORNER OF THE SQUARE, C. 1889 AND 1950. The first Denton bank opened in 1870 in the law office of Joseph A. Carroll and James M. Daugherty on the southeast corner of the square. The bank became Exchange National Bank in 1881. Denton County National Bank was organized in 1892 by 31 city leaders. In 1913, both banks constructed new buildings across Hickory Street from each other. Exchange National Bank failed in 1928 and First State Bank took over the southeast corner location. A new building was constructed on this site in 1961 and expanded in 1972. It is now home to Wells Fargo Bank. Denton County National Bank moved in 1962 to Hickory Street; now the offices for Denton Area Teachers Credit Union. The above photograph depicts the Exchange National Bank in the late 1880s while the photograph below shows the same corner in the 1950s. (Above, DPL; below, DRC.)

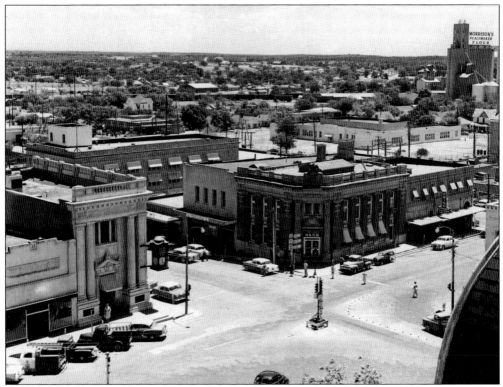

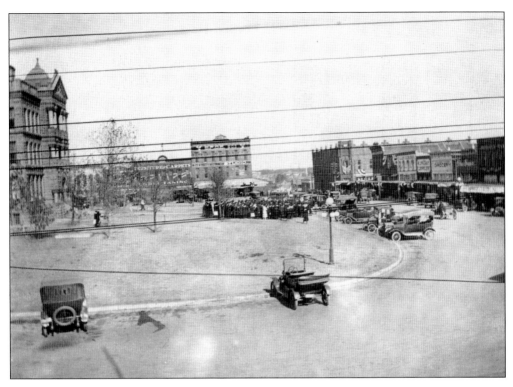

MAY BUILDING FIRE. These two photographs—with the same view—show the northeast side of the downtown square in 1918 and 1924. On November 9, 1924, fire destroyed the May Building, which housed Jarrell-Evans Dry Goods store (one of the oldest firms in the city), Guy Brothers Cafe, and the Knights of the Pythias Lodge. The building was replaced by the Smoot-Curtis Building, now known as the Texas Building. (DRC.)

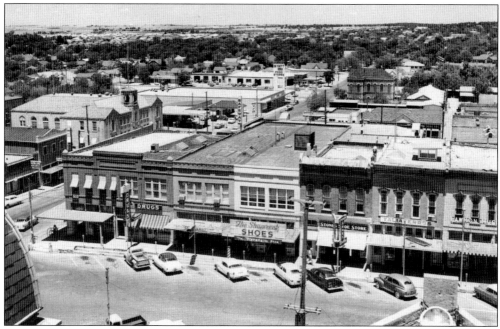

NORTH SIDE OF THE SQUARE, 1956. The downtown square served as the central business district in the mid-1950s. Businesses facing Oak Street included Blair Electric, Tobin's Drug Store, Denman Hardware, the Shamrock Shoes, Stone's Shoe Store, Taliaferro Hardware, Lawhon Music Company, Andrews Jewelers, North Side Shoe Shop, J. C. Penney Company, the Korral, and Glassman's Department Store. Insurance, doctor, and law offices occupied the Morris Building. Denton City Hall, Wyatt Food Stores, and the county jail appear in the background in the above photograph, while Texas State College for Women appears in the image below. (Both DRC.)

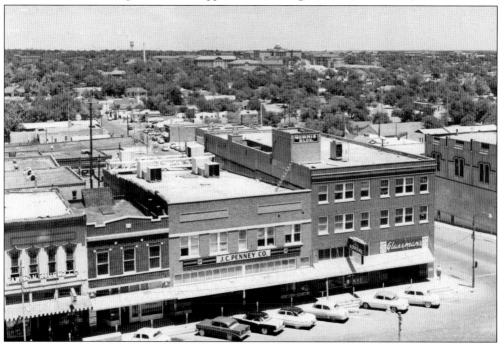

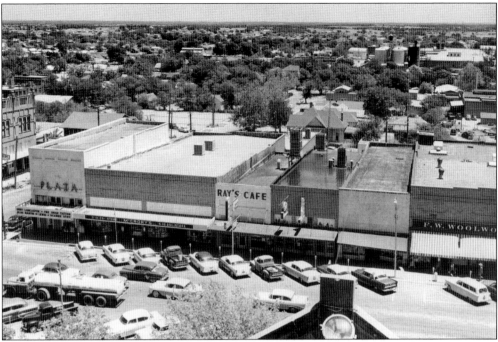

EAST SIDE OF THE SQUARE, 1956. Businesses facing Locust Street in these 1956 images are the Plaza Theatre, McCrory's Variety Store, Ray's Cafe, Fultz News Agency, Mutt's Vanity Shop, F. W. Woolworth and Company, Smart and Thrifty Dresses, and Denton County National Bank. The image below was taken after Reeves Drug Store, located at 106 North Locust, burned in January and the Williams Store, next to the bank building, closed in May 1956. (Both DRC.)

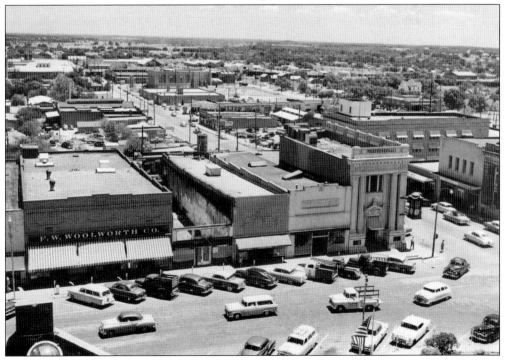

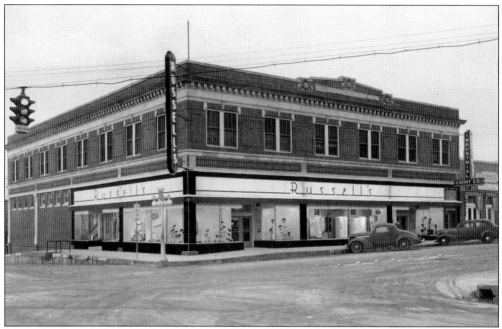

RUSSELL'S DEPARTMENT STORE. In 1897, H. Mason Russell opened his first store in Pilot Point. In 1924, he moved his store to the McClurkan Building on the southwest corner of the Denton Square. The store remained under family ownership until 1981 when it was sold and closed. A second store operated from 1969 until 2002 at Denton Center. In 1983, a third store opened in the former McClurkan department store in the Golden Triangle Mall but closed in 1989. The photograph below shows the interior of the downtown store in the 1960s taken from the mezzanine. (Both DRC.)

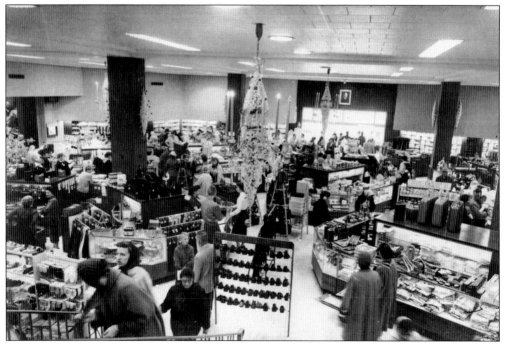

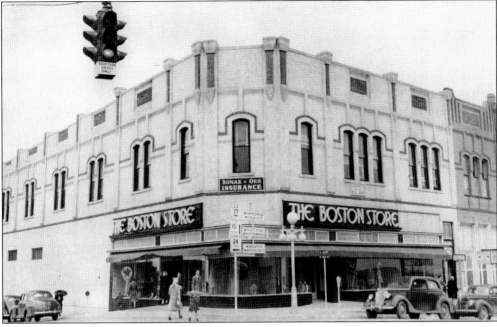

THE BOSTON STORE. In 1922, Martin Kornblatt opened the Boston Store on the west side of the square. He purchased the opera house from the Wright family in 1935 and operated the store in that location until it was sold to the Zales Corporation in 1967. Zales continued to run the Boston Store until the early 1970s. The photograph above shows the Boston Store in the early 1940s. Martin Kornblatt, who operated the Boston Store for 44 years, is shown in the image to the right. (Both DRC.)

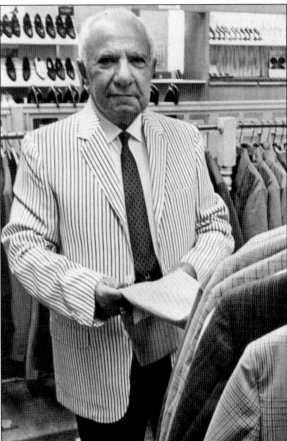

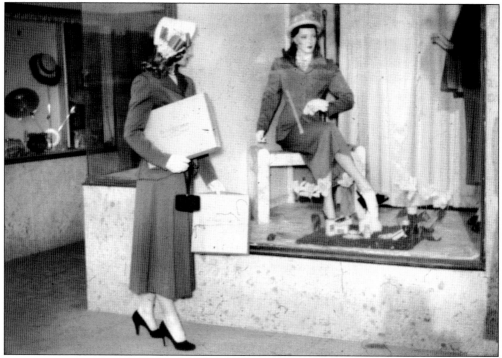

MUTT'S VANITY SHOP. Myrtle "Mutt" Richardson opened Mutt's Vanity Shop, a women's ready-to-wear shop, on Oakland Street in 1927 when she purchased a dress shop from Joan Blondell. She opened this Locust Street shop in 1934. The Oakland Street shop closed in 1949, and the shop on the square closed in 1963. Live model L'Jon Huffman is looking at a window mannequin identically dressed. (DCM.)

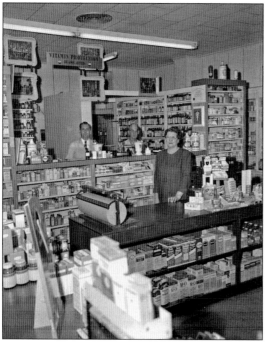

SHRADER'S PHARMACY. John B. Shrader and W. C. Shrader purchased the Swindle Pharmacy in 1944, one of Denton's oldest drugstores. In 1948, John B. Shrader Jr. took a partnership interest. When John Sr. died in 1955, his widow took his prior interest. W. C. Shrader retired in 1961. In this 1959 photograph are, from left to right, J. B. Shrader Jr., W. C. Shrader, and Eula Shrader. The pharmacy closed in 1998. (DRC.)

EVERS HARDWARE. Robert H. Evers and Adolph F. Evers opened their hardware store in 1885 on the south side of the square. They built the current structure at 109 West Hickory Street in 1913. Until the store closed in 2001, Evers Hardware was the longest operating business on the square. The building still bears the company name. (Courtesy of Celia and Mike Reid.)

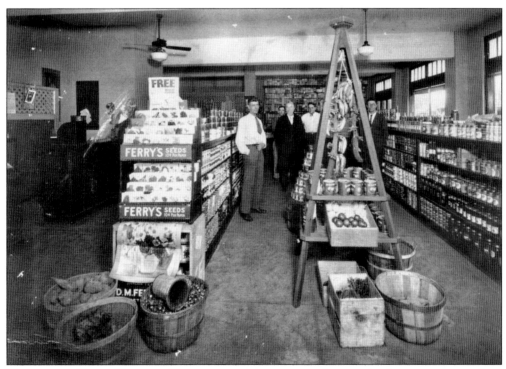

TURNER AND EVANS GROCERY. Grocery stores were commonplace on the downtown square from the founding of the city until the mid-1940s. Parking spaces were scarce and, by 1960, grocery stores completely deserted the square. This photograph shows the interior of the Turner and Evans Grocery store at 114 East Hickory Street. The man on the left is Sam Evans, and the third man from the left is Tom Turner. (DCM.)

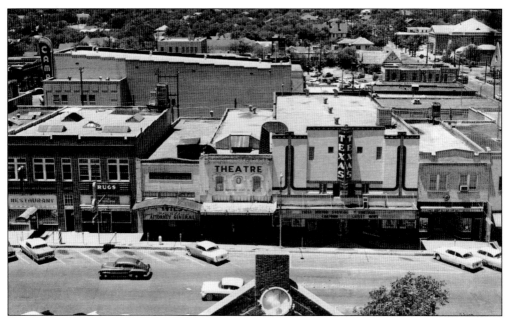

THEATER ROW. The Majestic opened on the north side of the square in 1909. The theater became the Princess in 1913, which burned down in 1924. The Dreamland opened in 1913 on Elm Street and was the beginning of "theatre row." The Palace opened in 1922 and the Texas in 1935. The Ritz opened in 1934 and was renamed the Plaza. By 1950, five theaters were located on the square. The Palace and the Dreamland closed in 1956, and the Texas was renamed the Fine Arts in 1957. The art moderne and art deco Campus Theatre opened in 1949 with the feature *I Was a Male War Bride*, starring Dentonite Ann Sheridan. The Campus Theatre's manager, J. P. Harrison, produced elaborate lobby displays advertising each film. The theatre closed in March 1985 and was remodeled and reopened in July 1995 as a live-performance venue. (Both DRC.)

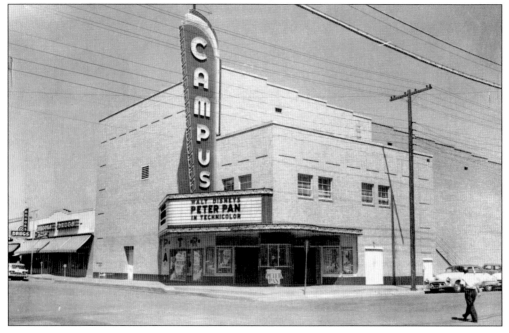

Two

MUNICIPAL AND INFRASTRUCTURE
THE PULSE OF THE CITY

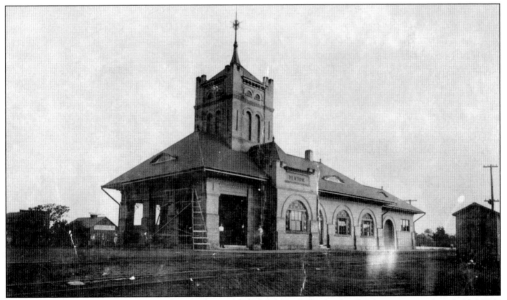

DENTON TRAIN DEPOT. The Texas and Pacific Railroad reached Denton on April 1, 1881, ushering in a new era of economic development. Built in 1900, the depot served passengers on the Texas and Pacific and Missouri-Kansas-Texas Railroads. The tower was removed and murals were added in 1948. Texas and Pacific Railroad passenger service was discontinued in July 1950, and the last Missouri-Kansas-Texas Railroad passenger train ran in December 1958. The depot was razed in 1964. (DCM.)

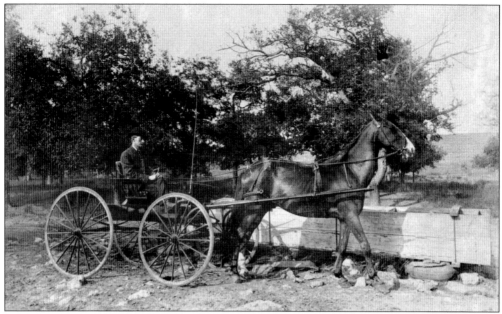

BUGGY TRANSPORTATION. Early Denton residents relied on the horse and buggy before the automobile. The back of this photograph includes an inscription, "Compliments of H. W. Ashby, Denton, Texas, to Miss Rosa Lee Delay, Mt. Sylvan, Texas, July 6, 1904. Picture of myself which my girl taken the last time we went riding and it was taken by Miss Bratcher who works at the Missippi [sic] store." (DCM.)

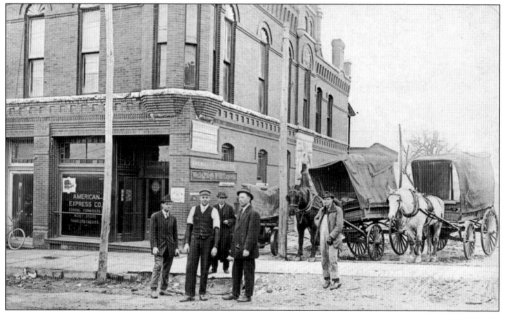

WELLS FARGO OFFICE. The Wells Fargo and American Express office was located at Ash, now Austin, and East Hickory Streets in the early 1900s. They transported goods and provided financial services. The Butterfield Stage line provided a similar service, carrying mail and goods until it was discontinued in March 1861. The last eastbound stagecoach passed through Denton on March 14, 1861. (DCM.)

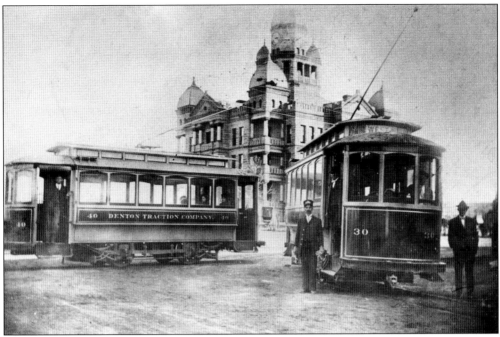

TROLLEYS. In 1907, the Denton Traction Company trolleys traveled along a 6-mile track from the railroad depot down Oak Street to the North Texas State Normal College and then to Highland Park where cars were stored. The line from Oakland Street to North Elm Street from the College of Industrial Arts was completed in 1911. Service discontinued in January 1918, and by April the tracks were taken up and salvaged. The above photograph depicts trolleys 30 and 40 as they converge at the courthouse. The photograph below features students from the Normal College enjoying a trolley ride. (Above, DCM; below, UNT.)

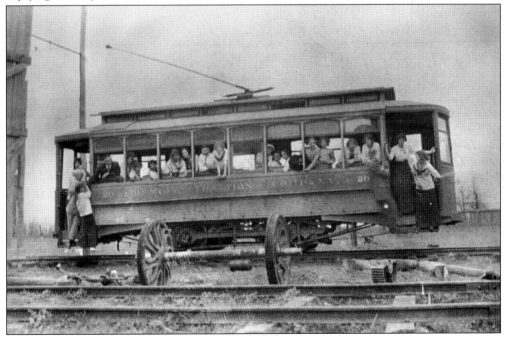

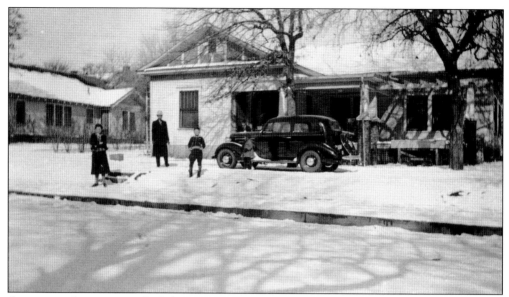

AGE OF THE AUTOMOBILE. On July 10, 1907, L. L. Fry registered his Cadillac as the first automobile in Denton. Not to be outdone, A. E. Graham registered his Cadillac the following day. L. L. Puckett registered two cars, one was a five-passenger Rickett and the other a Cadillac. The automobile age had arrived in Denton. The George Piott family proudly displays their automobile on their snow-covered front lawn in this 1930s photograph. (Courtesy of Verda Piott.)

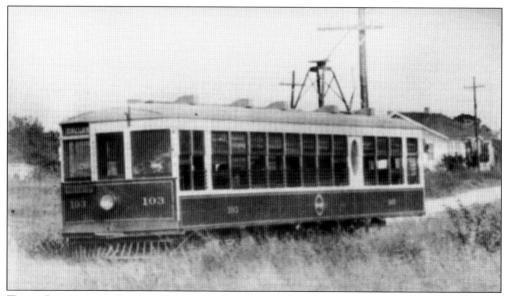

TEXAS INTERURBAN RAILWAY. In 1924, the Texas Interurban Railway electric train left the McKinney Street at Ash, later Austin, Street station at 42 minutes past the hour, 18 times each day. The train traveled along the tracks of the Missouri-Kansas-Texas Railroad. Three substations were built between Denton and Dallas. The train traveled at 27 miles per hour, which was a one-hour and 40-minute ride. Train service ended in the early 1930s. (DRC.)

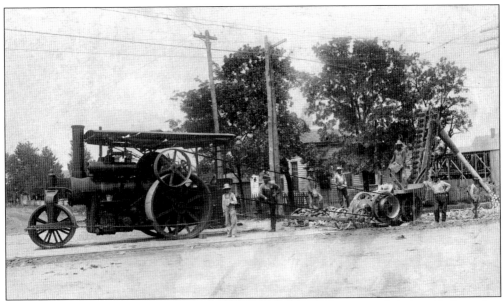

CONSTRUCTION OF EAST HICKORY STREET. The coming of the automobile heralded another development in Denton's transportation network—the paving of city streets. In this photograph, the first base for East Hickory Street is being laid by one of Zeph Wiggs's crews, who paved many of the first streets in Denton. This photograph was taken in 1910 at the corner of Ash and Hickory Streets. Zeph Wiggs is shown second from the right, but the identities of the workmen are unknown. (DPL.)

SOUTH LOCUST STREET. Prior to the construction of the interstates, Locust Street was one of the main thoroughfares into town. By the 1930s, more people were traveling by automobile. Denton catered to this new tourism boom with the construction of tourist courts. This photograph shows the Hammond and Kirby Tourist Camp at 903 South Locust, built in 1938 with the courthouse in the background. (DRC.)

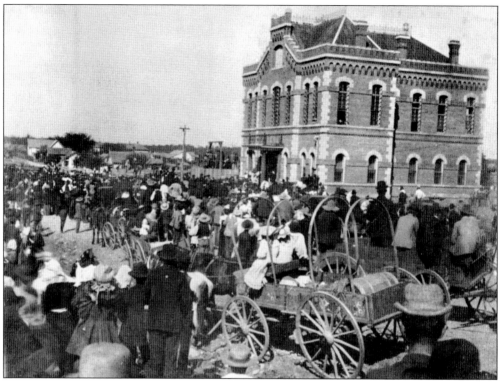

THE JAIL AND THE LAST HANGING. This jail housed its first prisoners in 1892 and included living quarters for the jailer and his family on the first floor and cells on the second floor. John Quincy Adams Crews was tried for murder in 1895 and found guilty. Crews is shown here being hanged outside the jail on October 14, 1895, which was the last execution in Denton County. The building was torn down in 1964. (DPL.)

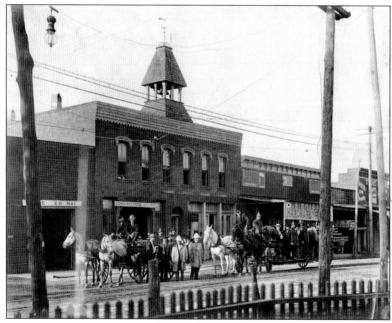

DENTON CITY HALL AND FIRE HOUSE. This 1879 building, located at Bolivar and West Oak Streets, was purchased by the city in 1890 for use as city hall, jail, and firehouse until 1927. The fire station was on the ground floor, with the jail in the back and city hall and offices upstairs. The building was demolished in 1931. (DPL.)

DENTON POLICE DEPARTMENT.
The City of Denton assumed
responsibility for its law
enforcement in 1873 with the
creation of the city marshal's
office. In 1939, the city commission
officially designated the position as
chief of police and the office as the
Denton Police Department. The
three officers, holding .38 caliber
snub nose revolvers they won in
a pistol competition are, from left
to right, James McDonald, Allen
Lewis, and Greg Anderson. (DPL.)

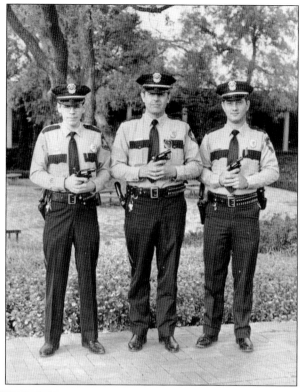

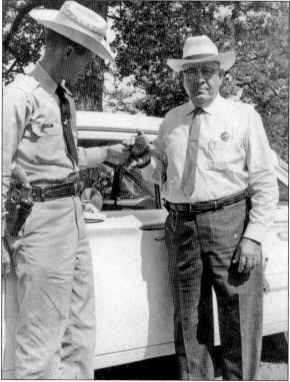

**SAMUEL RICHARD GENTRY (1893–
1992).** Samuel "Sam" Gentry (right)
was a peace officer in Denton for
39 years, 10 of which he served
on the Denton police force, 5 as
deputy sheriff, and 24 as constable
Precinct One, retiring in 1973 at
the age of 79. Gentry was the first
officer to wear a city police uniform
and to use a police car radio.
This photograph is of Constable
Gentry with Bill Long, state game
warden. (Courtesy of Bill Gentry.)

DENTON POST OFFICE. The above photograph, provided by contractors Cooper and Lund, Contractors, is of the post office under construction at 210 North Locust Street on November 3, 1919. Taken from the northeast, the courthouse spire appears in the center of the background. The post office served the public for 55 years until a new post office building was constructed on McKinney Street. The image below shows the building in use in the late 1950s. (Above, DRC; below, DPL.)

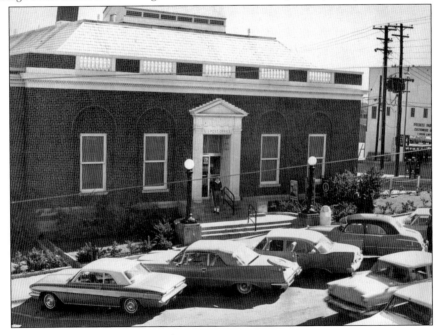

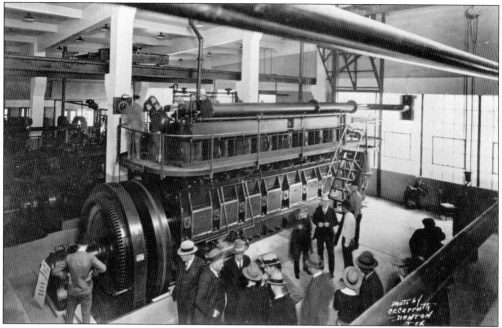

CITY POWER PLANT, 1930. The Denton Water, Light, and Power Company built the first power plant in 1892. The city bought the plant from the power company in 1905, and in 1929 the city constructed a new power plant at 414 East Hickory Street. This photograph shows the building at the dedication on March 19, 1930. (DRC.)

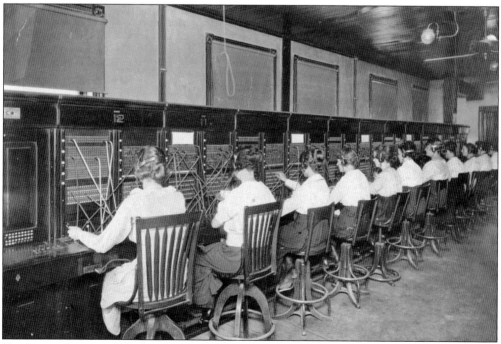

TELEPHONE SERVICE. Telephone service came to Denton in 1896. Working the switchboard, Flo Crout and Julia Crout are the third and fifth girls from the left in this 1919 photograph. The office was located on West Hickory Street where the Verizon Building is now. (DCM.)

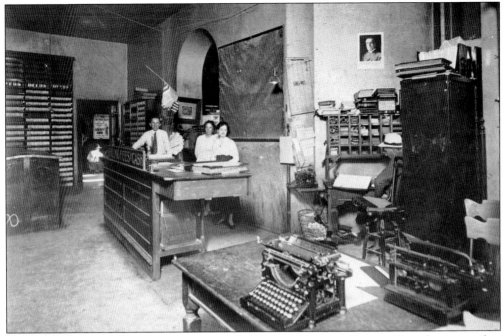

1896 COURTHOUSE. The cornerstone was laid for the Denton County Courthouse-on-the-Square on February 8, 1896. Built primarily of limestone from the William Ganzer farm quarry, the structure was designed by W. C. Dodson with Tom Lovell as construction manager. The building featured a district courtroom on the second floor with an overlooking balcony. Despite several alterations over the years, most county offices outgrew the building and moved in 1978. The courthouse currently houses the offices of the county judge, commissioners' court, and the historical commission and museum. These are Dodson's original blueprints for the floor plan for the third floor of the courthouse. The 1918 photograph seen above is of the Denton County clerk's office that occupied the south end of the first floor. (Above, DCM; below, DPL.)

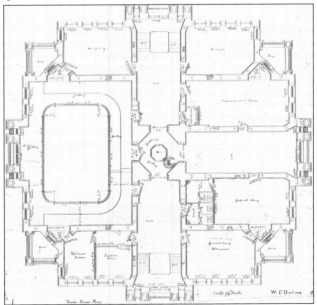

DENTON CITY HALL. Gov. Dan Moody dedicated Denton City Hall, at 221 North Elm Street, on October 9, 1927. This Spanish-style building was home to all city government offices and a large auditorium. It also housed a fire department in the basement. Several city offices moved in 1967 when the new city hall was built. This photograph was taken December 5, 1968. (DPL.)

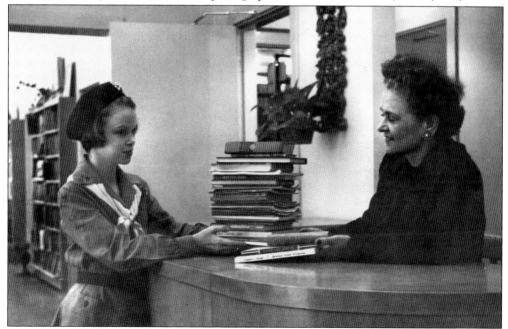

EMILY FOWLER PUBLIC LIBRARY. In 1935, the Denton County School Library opened with 2,276 books in the courthouse basement. Emily Fowler became the librarian in 1943, and in 1949 the library moved to the city park. O'Neil Ford designed a building addition in 1969. Upon Fowler's retirement, the Emily Fowler Public Library was renamed in her honor. This photograph depicts Mary Lou Burford from Troop 15 giving books furnished by the Girl Scout Council to Emily. (DPL.)

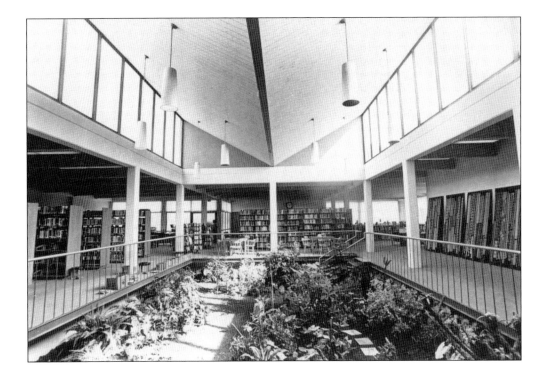

LIBRARY ATRIUM AND CIVIC CENTER. O'Neil Ford designed five significant structures in Denton, including the municipal swimming pool (1965), the Denton Civic Center (1966), Denton City Hall (1967), Denton Airport Air Terminal (1967), and Emily Fowler Library additions (1969 and 1981). The library atrium, pictured above, reflects Ford's innovative use of nature in his designs. The intricate use of cables and pipes that support the roof of the Denton Civic Center is based on the design of a bicycle's hubbed wheel. This cable-suspension system frees the large interior from internal supports. Ford was named a National Historic Landmark by the National Council of the Arts. (Both DPL.)

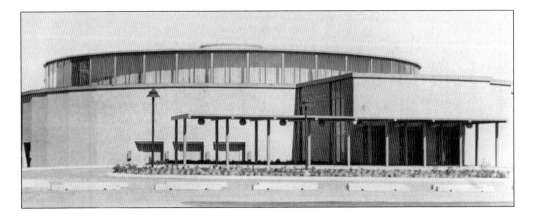

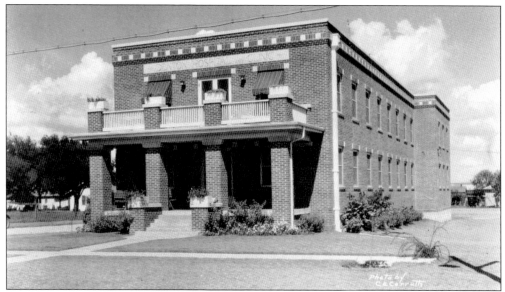

DENTON HOSPITAL AND CLINIC. The Denton Hospital and Clinic opened in 1926 at 525 South Locust Street under the management of Drs. A. R. Ponton and M. L. Hutcheson. The hospital featured 30 patient beds, an operating room, delivery room, emergency room, and labs. Dr. M. L. Holland assumed control in 1935 and was joined by his nephew, Dr. Joe Holland, in 1947. The private hospital closed in 1955. (Courtesy of Virgil and Gayle Strange.)

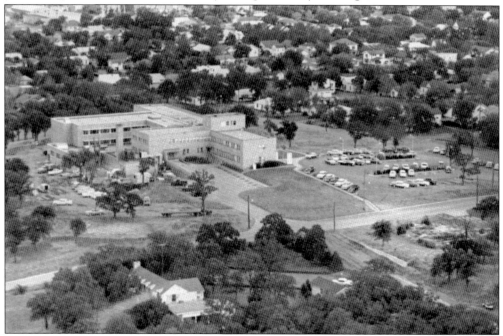

FLOW MEMORIAL HOSPITAL. In 1946, Homer E. Flow died and left his estate, valued at $150,000, to the county and city for a public hospital. The county and city purchased land on Scripture Hill between Bryan and Ponder Streets. The brick three-story, 60-bed hospital was dedicated on September 3, 1950. It closed as the county and city hospital in 1988, was purchased by Denton Regional Medical Center in 1989, and was torn down in 2002. (DRC.)

CITY PARK. The City of Denton created its first public park after purchasing and removing the African American community of Quakertown in the early 1920s. The city built a playground, swimming pool, and baseball field on the park grounds. Citizens are enjoying leisure time in this 1930 photograph. (DCM.)

CASCADE PLUNGE
WELCOMES YOU

Denton's OLD SWIMMING HOLE is a cemented pool of clean, constantly running artesian water, warmed or cooled to the desired temperature.

Well lighted and open air, no dark corners at Cascade Plunge.

The general welfare of the young and the old alike, as well as the conduct and general supervision of this playhouse is personally supervised at all times by

MR. AND MRS. R. J. WILSON
512 BOIS D'ARC STREET

CASCADE PLUNGE. This swimming pool opened in June 1919 across from the Alliance Milling Company. A large board fence was built around the pool to protect female swimmers from the prying eyes of mill workers. Beauty contests were held at Cascade Plunge in the 1930s. Seth Massey escorted Clara Lou Sheridan (Ann Sheridan) to a swimming pageant at Cascade Plunge where she won first place and the title of Miss Denton. (DPL.)

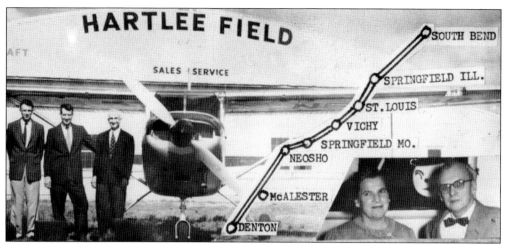

HARTLEE FIELD. When the city's application for a municipal airport was denied, George Harte and his wife, Beatrice Lee, purchased the property, built hangers and runways, and opened Hartlee Field on September 22, 1941, to train U.S. Army–Air Force Liaison Pilots. He trained 4,000 pilots in two years, including future astronaut Alan Shepherd. After the war, Hartlee Field became a private airstrip as depicted in this 1958 advertisement. (DRC.)

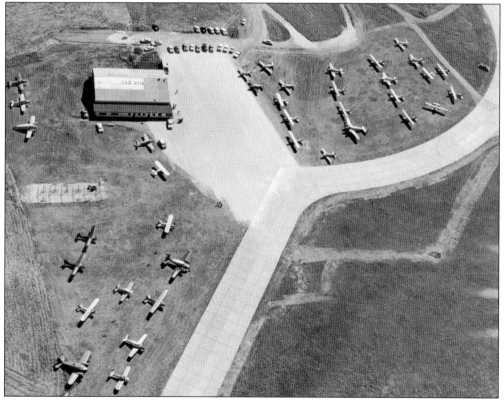

DENTON MUNICIPAL AIRPORT. The city purchased a 550-acre site southwest of town in 1943 to build a glider airport. A high accident rate cancelled the plans. The airport was completed in 1947 with a single concrete runway 4,150 feet in length and 150 feet wide. Since its initial construction, Denton Municipal Airport has undergone several modifications. (DRC.)

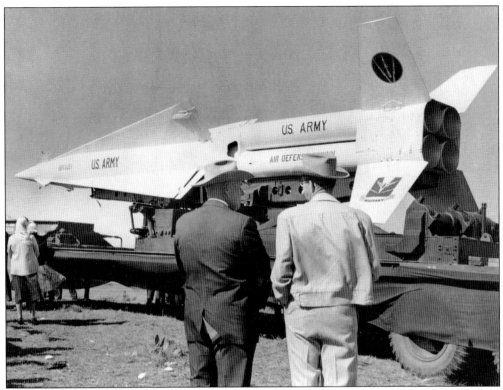

NIKE MISSILE BASE. In 1959, at the height of the Cold War, the U.S. Army constructed a Nike-Hercules guided missile base north of Denton. Surface-to-air missiles were designed to destroy an entire fleet of supersonic aircraft. Three underground facilities stored the missiles. The base was manned 24 hours per day, first by the 4th Missile Battalion, 562nd Artillery and then by the Texas Army National Guard in 1964. The base was closed in 1969 and the property was transferred to the city. The above photograph is of a Nike-Hercules missile on display at the ground-breaking ceremony on November 7, 1958. The photograph below, taken in 1968 just before the base closed, is of National Guardsmen Chief Warrant Officer Williams and base commander Capt. William Byrd. (Both DRC.)

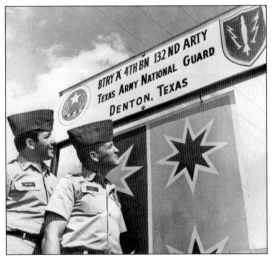

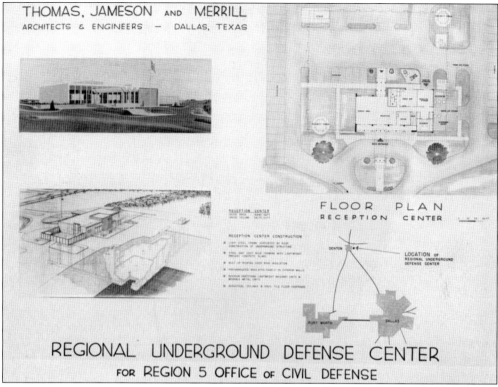

THOMAS, JAMESON AND MERRILL
ARCHITECTS & ENGINEERS — DALLAS, TEXAS

FLOOR PLAN
RECEPTION CENTER

REGIONAL UNDERGROUND DEFENSE CENTER
FOR REGION 5 OFFICE OF CIVIL DEFENSE

FEDERAL EMERGENCY MANAGEMENT AGENCY. The Office of Civil Defense and Mobilization opened the nation's first federal underground center in Denton in 1964. This $2.5 million control center and underground bomb shelter could provide living arrangements for 500 federal officials. This is the architectural plan of the Federal Emergency Management Agency (FEMA) regional center, located on Texas State Highway Loop 288. In 1959, Sen. Lyndon B. Johnson visited Denton to inspect the site. (Above, DRC; below, DPL.)

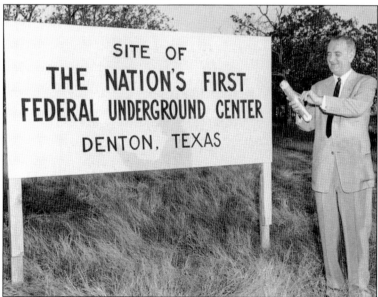

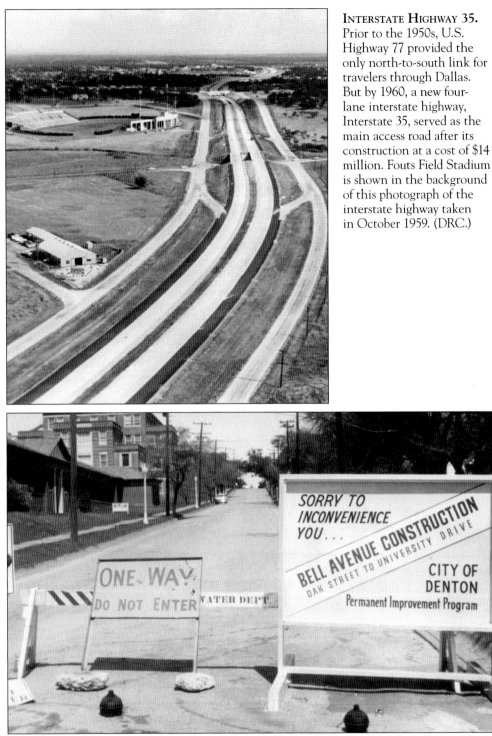

INTERSTATE HIGHWAY 35. Prior to the 1950s, U.S. Highway 77 provided the only north-to-south link for travelers through Dallas. But by 1960, a new four-lane interstate highway, Interstate 35, served as the main access road after its construction at a cost of $14 million. Fouts Field Stadium is shown in the background of this photograph of the interstate highway taken in October 1959. (DRC.)

> SORRY TO
> INCONVENIENCE
> YOU . . .
>
> BELL AVENUE CONSTRUCTION
> OAK STREET TO UNIVERSITY DRIVE
>
> CITY OF
> DENTON
> Permanent Improvement Program

> ONE WAY
> DO NOT ENTER WATER DEPT.

BELL AVENUE. Road improvement projects are a familiar sight in the city. Construction on Bell Avenue from Oak Street to University Drive is depicted here in 1961. Citizens will see the humor in this sign that reads, "City of Denton Permanent Improvement Program." (DRC.)

Three

BUSINESSES
THE BACKBONE OF THE CITY

THOMAS E. TAYLOR'S THRESHING MACHINE. As a result of the arrival of the railroad, a shift occurred from subsistence agriculture to cash crops. The principal crops became cotton, corn, and wheat. Farmers flourished with the cultivation of these cash crops. By 1884, Denton County was the leading wheat-producing county in Texas. Early industries included a cotton gin, mills for grinding cornmeal and flour, and pottery production. (DCM.)

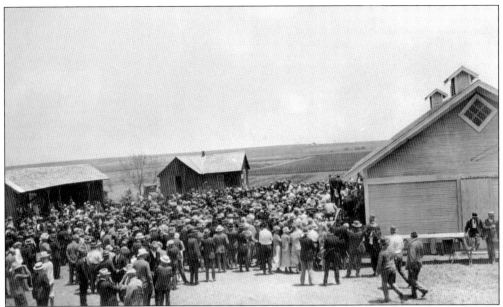

TEXAS AGRICULTURAL EXPERIMENT STATION NO. 6, 1927. Texas Agricultural Experiment Station No. 6 was established in 1910 near Highland Park in Denton to conduct research into every phase of crop and livestock operations in North Texas. Later the experiment station moved 5 miles northwest of downtown to a 203-acre site and served as an agricultural testing facility for more than 60 years. (DCM.)

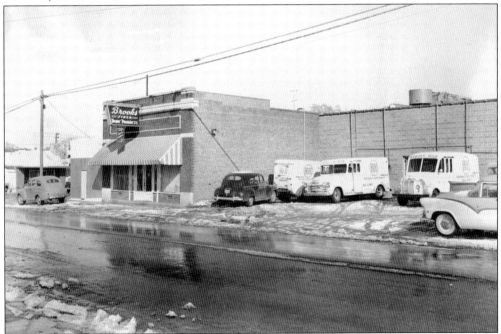

DENTON DAIRY PRODUCTION. T. R. Brooks began his dairy business in 1910 with three jersey cows. In 1920, he built a milk plant at the corner of Avenue D and Mill Street. The Brooks Dairy moved to North Locust Street in 1932. This 1960 photograph is of the Brooks Dairy Store and delivery trucks at that location. The Brooks family sold the dairy in 1967. (DRC.)

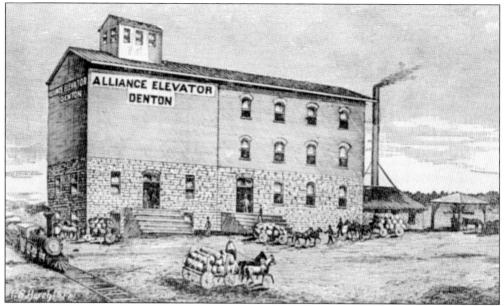

ALLIANCE MILLING/MORRISON MILLING COMPANY. The Denton County Farmers Alliance formed a cooperative mill and elevator in 1886. James Newton Rayzor served as manager and then president of the mill. Alliance Milling's Peacemaker Flour won the 1900 Centennial Exposition gold medal in Paris, France, and the gold medal at the 1904 World's Fair in St. Louis, Missouri. The prizewinning flour won the Texas State Fair premium award for many consecutive years until it was barred from competition. Over the years, the company added the capacity to mill corn from local farmers into cornmeal, producing some of the finest cornmeal products available. In 1936, the company was purchased by E. Walter Morrison Sr. and renamed the Morrison Milling Company. In 2006, C. H. Guenther and Son purchased the mill and retained the Morrison Milling Company name. (DCM and DPL.)

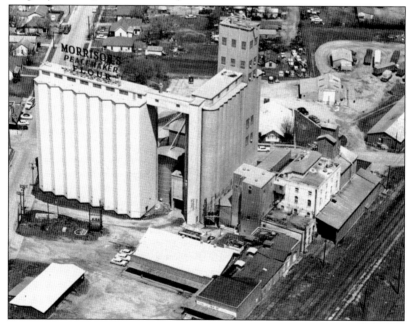

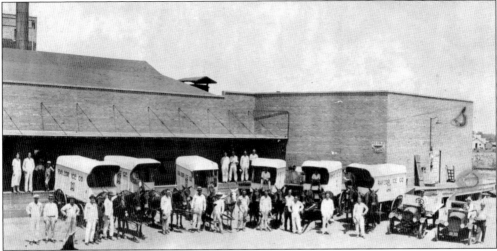

RAYZOR ICE PLANT. The Alliance Milling Company formed the ice company in 1901 and sold the company to the Rayzor family in 1924. Ice was delivered by mule-drawn wagons to customers throughout the county. In 1926, the Commonwealth Utilities Company of St. Louis purchased Rayzor Ice Plant and the Crystal Ice Plant. After the advent of home refrigeration, ice production remained a lucrative business into the 1960s. (DCM.)

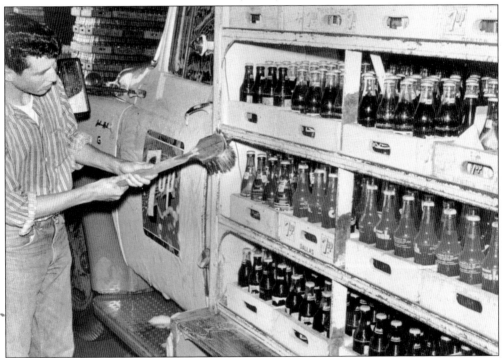

DENTON BEVERAGE COMPANIES. Denton's bottling history dates to the 1890s when Alliance Bottling Company and Denton Bottling Works started bottling soft drinks. In 1926, 7-Up Bottling was established with 7-Up, Mission Rootbeer, and NuGrape as their main products. Coca-Cola Bottling Works opened at 301 Oakland Street in 1922. Mission Beverage Company, a subsidiary of Whitson Food Products, was one of the first companies in the nation to produce canned, carbonated beverages. (DRC.)

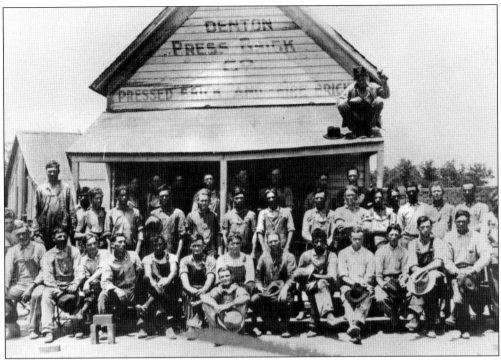

DENTON PRESS BRICK COMPANY/ACME BRICK COMPANY. The Denton Press Brick Company was established in 1901 by William Bryce. In 1911, George Bennett, owner of Acme Pressed Brick Company, and William Bryce formed the Denton branch of the Acme Brick Company. Acme Brick Company workers are shown above in a 1914 photograph at the original Denton Press Brick Company sales office. In 1918, the brick company was modernized to automate brick making by extruding the moist clay into "stiff mud" bricks. The image below, an aerial view of the Acme Brick Company, was taken around 1960. (Both DCM.)

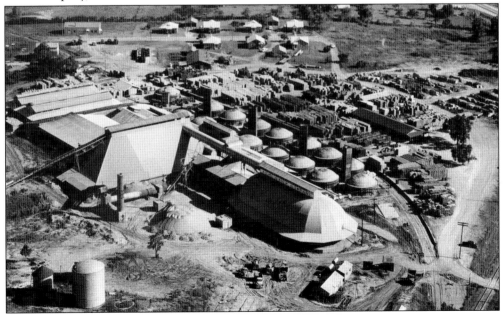

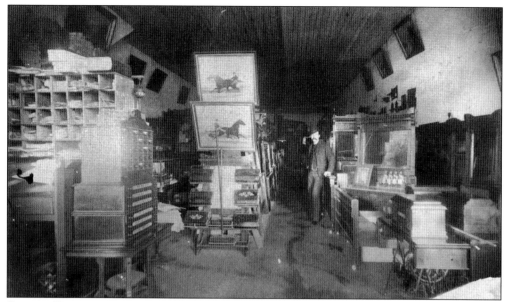

SCHMITZ FURNITURE AND FUNERAL HOME. John B. Schmitz, a cabinet and organ maker by trade, came to Denton in 1878 to establish a furniture store. In 1890, he sold furniture and funeral caskets in a building on Oak Street. During the fire of 1924, the Schmitz store suffered extensive smoke damage. In 1925, the store was moved to 207 North Elm Street and operated at that site until 1960. The above photograph is of the Schmitz Furniture Store on Oak Street. Often furniture stores sold caskets and performed mortuary services. John B. Schmitz's son Jack opened a funeral home, Jack Schmitz and Sons, at 705 North Locust Street in 1947. The 1956 photograph seen below shows the funeral home and the new ambulance. (Above, DPL; below, DRC.)

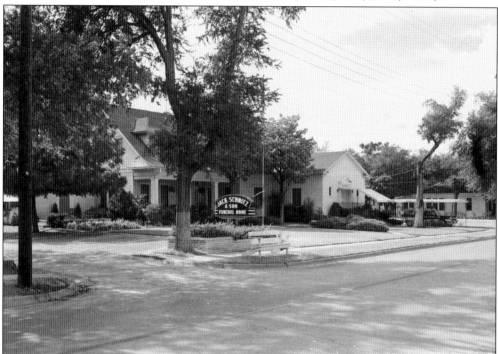

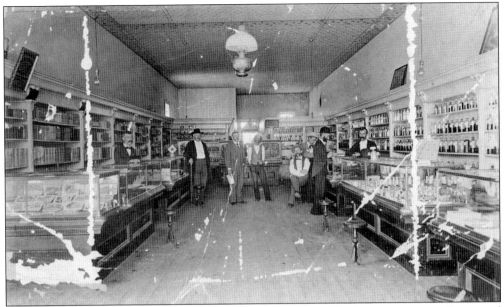

MINNIS AND CURTIS DRUG STORE. Numerous drugstores were on the downtown square. Smoot and Curtis Drug was opened in 1900 by W. D. Smoot and O. M. Curtis. In 1902, J. A. Minnis bought Smoots' interest and the name became Minnis and Curtis Drug. The men in this photograph are, from left to right, J. A. Madden (behind showcase), unidentified, Dr. J. M. Inge, unidentified, unidentified, Fred Hutchison, Mr. Shehay (drug drummer), and J. A. Minnis (druggist). (DPL.)

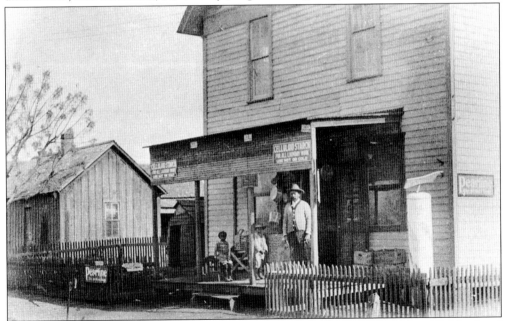

CRAWFORD'S STORE. B. F. "Ford" Crawford operated a grocery store at the corner of Oakland and Holt Streets in the African American community of Quakertown. The Odd Fellows met on the second floor. His son Bert briefly operated a funeral home out of the store until he constructed his own building. The store closed in 1922 when the city removed Quakertown and the family moved to Wichita, Kansas. (Courtesy of Mike Cochran.)

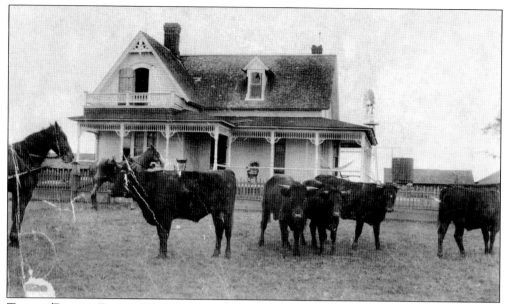

Turner/Rayzor Ranch. This photograph is of the original Turner ranch, built in the 1870s and the site of a successful cattle-raising operation. J. Newton Rayzor purchased the house and 289 acres in 1955 and tore down the house in 1962 to build his summer home, Hill View Ranch. The land at the corner of Bonnie Brae and Scripture Streets is known to most Denton residents as the Rayzor Ranch. (DCM.)

Cattle Auction. After the coming of the railroads in 1881, dairy cows replaced trail-driven beef cattle as an important industry in Denton. According to the 1930 census, there were 34,000 cattle in Denton County. Cattle raisers throughout the county brought their stock to Denton for sale and trade. This 1950s photograph was taken in a field near Exposition Street. (DCM.)

PITNER PACKING COMPANY. John Michael "Doc" Pitner, a licensed veterinarian, founded the Pitner Packing Company in 1927. His son, Homer Melton "Doc" Pitner, joined his father's business in 1943. When J. M. Pitner's health failed, Floyd Hensley joined the firm in 1947. The plant, which filled special orders, shipped Doc Pitner sausage as far away as Germany. In this 1957 photograph are, from left to right, Floyd Hensley, Red Wilcox, and Les Lawson. (DRC.)

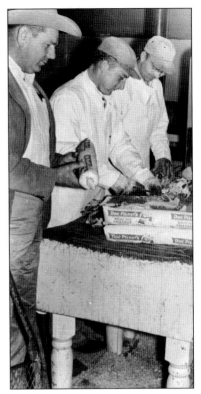

WILLIAMS' PONY FARM. Will Williams established his Shetland pony farm in 1910 off Taylor Lake Road. By 1951, Williams registered more Shetland ponies with the American Shetland Pony Club than any other breeder in the United States. One of the ponies gained fame performing for the Ringling Brothers Circus with a monkey ballerina on her back. This photograph is of Williams and his silver-dapple stallion, Reveille Patton. (DRC.)

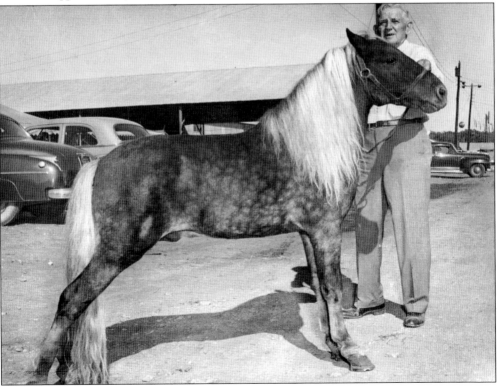

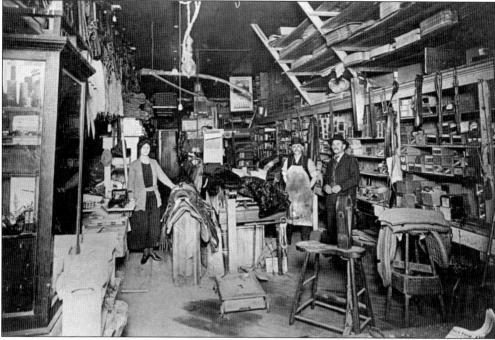

KANADAY SADDLE SHOP. In 1916, S. Wallace Kanaday operated a seed and general merchandise store. He opened a saddle shop on West Oak Street due to the popularity of horse racing and ranching in Denton. This is a 1921 interior view of the saddle shop. The man in the center is S. Wallace Kanaday. (DPL.)

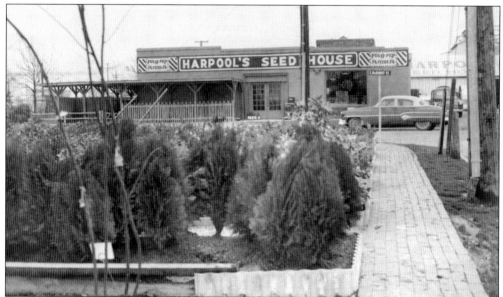

HARPOOL SEED AND NURSERY. R. T. Harpool Sr. and his sons were in the agricultural supply business. Tom and his father operated R. T. Harpool and Son from 1939. Tom purchased Farmers Exchange and the Seed House in 1940, which became Harpool Garden Center and Harpool Seed Inc. Al Harpool operated the landscape department. Walter S. "Pinky" Harpool owned Harpool Fertilizer Company. (DRC.)

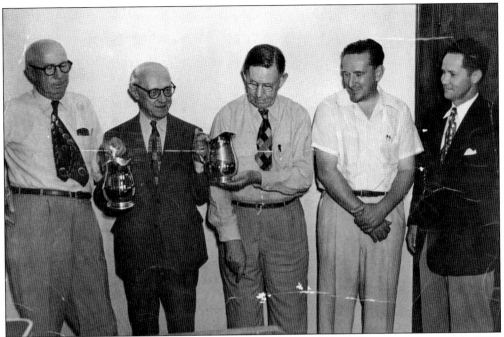

RAMEY AND KING INSURANCE. Oliver Perry Poe started Denton's first insurance agency in 1881. M. L. Ramey bought the company in 1920, and Abney Ivey became a partner in 1923. In 1946, Ramey's son Marvin took over and eventually purchased Abner Ivey's interest. In 1962, Terrell W. King III became a partner and the company became Ramey and King Insurance. This photograph includes, from left to right, Abney Ivey, M. G. Garreau, M. L. Ramey, Marvin Ramey, and Herbert West. (Courtesy of Iris Ramey.)

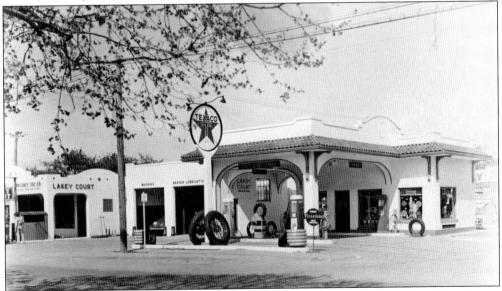

LAKEY TOURIST COURT AND LANEY SERVICE STATION. This picture shows the Lakey Tourist Court and the Sam Laney Service Station and Tire Company located at 502–504 North Locust Street, built in 1930. The Hammond and Kirby Tourist Camp and the Lakey Tourist Court provided travelers with overnight accommodations and covered parking. (DPL.)

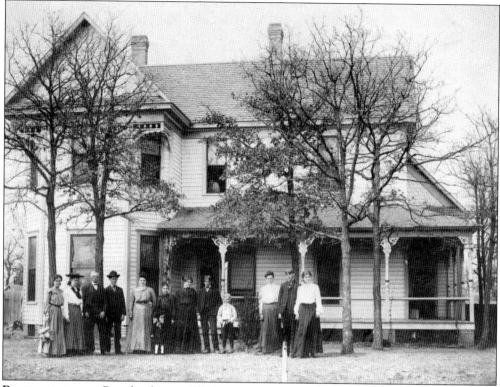

BOARDINGHOUSES. Boardinghouses filled an important need for student housing and income for the families who operated them. By 1910, more than 80 private boardinghouses were used by students. This 1905 photograph shows Thomas and Sarah Taylor's home on West Hickory, a popular boardinghouse for Normal School students. (DCM.)

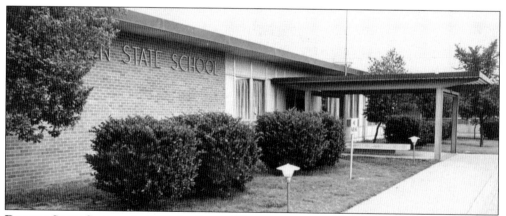

DENTON STATE SCHOOL. In 1957, the State of Texas appropriated $2 million to establish a special school for individuals with developmental disabilities. The city optioned a 204-acre site as part of its bid for the school, and 2,000 people donated between 21¢ and $2,000 to raise the $102,000 to purchase the site. The Denton State School opened in 1960 and serves more than 600 people. This photograph is of the Administration Building. (DRC.)

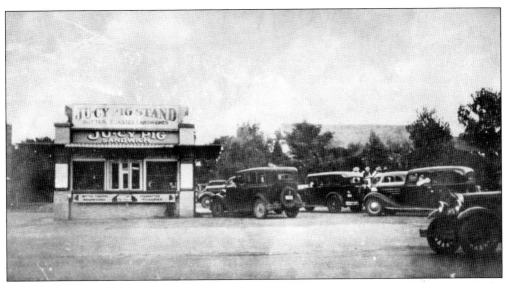

JU-CY PIG RESTAURANT. Ralph P. Shannon and J. C. Burch operated a popular restaurant, the Ju-Cy Pig, at 410 North Locust Street from 1932 until the early 1970s. Shannon took numerous slides, which he projected onto the wall of neighboring Brooks Dairy for the entertainment of his customers. This 1936 photograph depicts the Ju-Cy Pig stand before it became a sit-down restaurant. (DRC.)

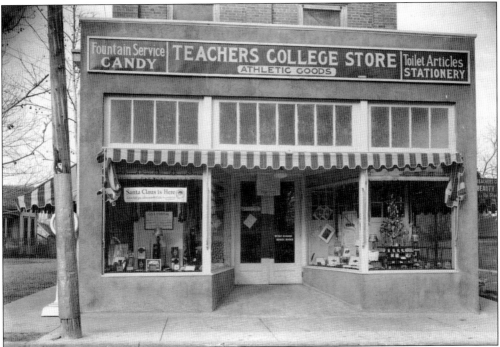

TEACHERS COLLEGE STORE, 1925. Roy Voertman began the Teachers College Store in 1925. His son Paul took over in 1952 with the intention of making the store profitable enough to sell. He accomplished his goal quickly and remained at the store's helm until 1990 when he sold the business to the Nebraska Book Store. Voertman's Bookstore became a landmark near the University of North Texas campus. (Courtesy of Paul Voertman.)

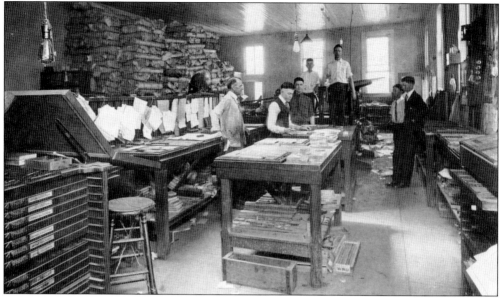

DENTON RECORD-CHRONICLE NEWSPAPER. The *Denton Chronicle* was established 1882, followed by the *Denton Record* in 1898. They merged in 1899 and were purchased by Will Edwards in 1901, becoming the *Denton Record and Chronicle*. It became a daily newspaper in 1903. In the newspaper's 100-year history, the *Denton Record-Chronicle* has had three owners—the Edwards', the Cross family, and A. H. Belo Corporation. The above photograph depicts the interior of the *Denton Record-Chronicle* office in 1918. The photograph below was taken in the *Denton Record-Chronicle* newsroom. (Above, DCM; below, DRC.)

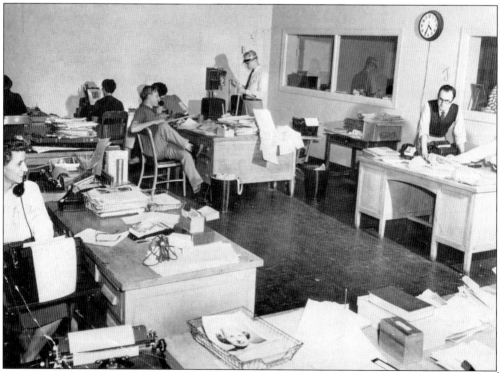

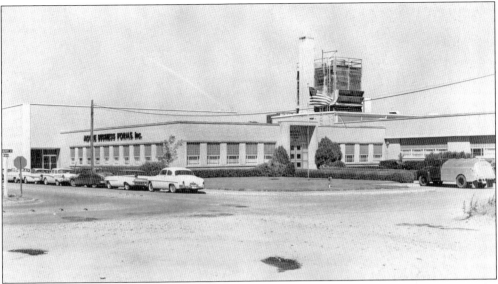

MOORE BUSINESS FORMS. Samuel J. Moore founded the Moore Business Forms in 1882. The Southern Division Home Office began production on May 26, 1947, in Denton. Moore Business Forms was the world's largest manufacturer of business forms and machines. The Denton plant was responsible for sales and production in 13 states until the plant closed in 1987. (DRC.)

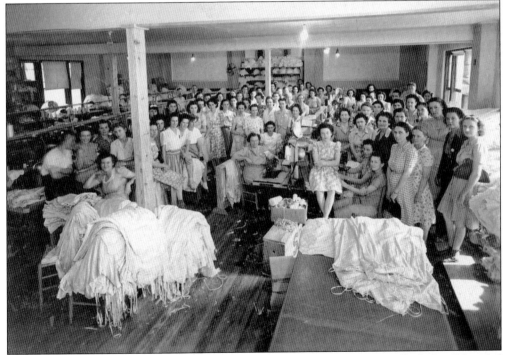

RUSSELL-NEWMAN MANUFACTURING COMPANY. Rowe Boyd Newman and J. Holford Russell founded Russell-Newman Manufacturing Company in 1939 in a small building on West Oak Street with five employees. The company became one of the nation's largest manufacturers of men's, women's, and children's intimate apparel under the leadership of Frank Martino, Newman's son-in-law, and his sons. A group of Russell-Newman employees is shown here in the 1940s. (DPL.)

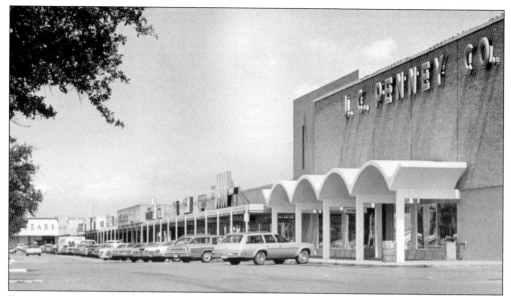

DENTON CENTER. When the 53-acre Denton Center opened in 1960, the center was the first shopping venue away from the square. Anchored by Skillern's drugstore, Wrigley's supermarket, M. E. Moses, Tiny Togs, and a barbershop were the first stores to open. The Zales Corporation; Pargas; Voertman's Bookstore; a doughnut shop; a record shop; a paint store; a fabric shop; a dress shop; J. C. Penney; Sears, Roebuck, and Company; and Luby's Cafeteria followed in the next two years. (DRC.)

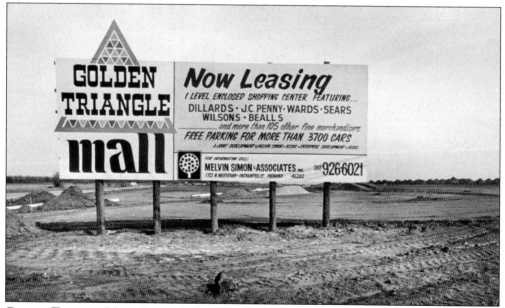

GOLDEN TRIANGLE MALL. Denton's first fully air conditioned mall opened in 1980 at Interstate Highway 35 East and Texas State Highway Loop 288. Shoppers in Denton now had the opportunity to choose from 105 retailers under one roof. (DRC.)

Four

EDUCATION
THE MIND OF THE CITY

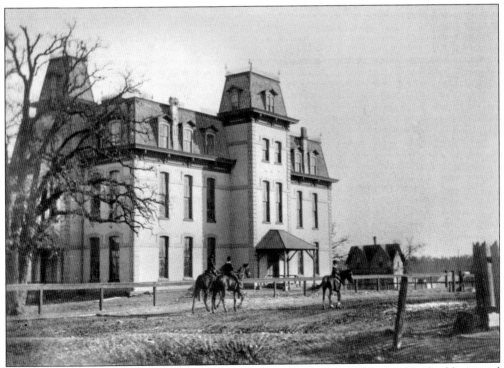

FIRST PUBLIC SCHOOL. Early Denton subscription schools were held in public buildings and private homes. The Masons established a school in their lodge in 1860. In 1871, the Independent Order of Odd Fellows (IOOF) built a school one block southeast of the square. Denton became an independent school district in 1881. The first building opened at the Independent Order of Odd Fellows site in April 1884 and contained all grades until 1899. The building burned in 1908. (DRC.)

CENTRAL SCHOOL/ROBERT E. LEE. Built on the original Central School site, Robert E. Lee School was dedicated in 1909 with William Jennings Bryan as speaker. Prior to 1912, all high school students attended this school until the school district purchased the John B. Denton College and the Robert E. Lee School became an elementary school. A new building was constructed in 1923. The Robert E. Lee School was relocated to Mack Place in 1974, and the old building was demolished. The seventh-grade student photograph seen below was taken on July 13, 1900, on the steps of the old Central School building. Etta Jones (front row, third from the right) was the teacher. (DPL and DCM.)

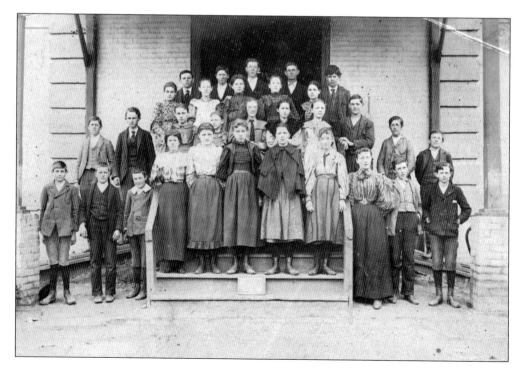

STONEWALL JACKSON SCHOOL. Located between North Elm and Locust Streets, North Ward School opened in 1899. In 1909, the school's name changed to the Stonewall Jackson School. The original building burned and another one was erected in 1916. The school was phased out in 1982–1983. In 1986, the old structure was torn down and a new central administration building was constructed. The above photograph is of the 1916 building. The image below is of the first first-grade class at the North Ward School. (Above, DRC; below, DCM.)

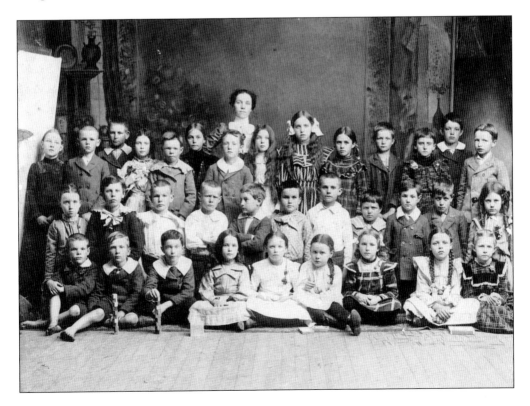

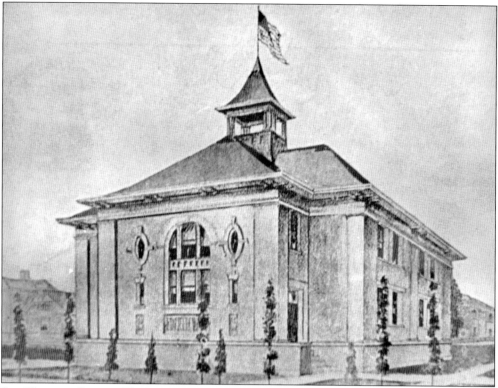

SAM HOUSTON SCHOOL. The West Ward School was built on Welch Street in 1905 and was renamed Sam Houston School in 1909. The Sam Houston School closed in 1974 when the building was purchased by North Texas State University and used for university purposes until 1985. A new Sam Houston Elementary School was opened in 1982 on Teasley Lane. The 1908 second-grade class is shown below with teacher Blanche Hoskins at top left of photograph. (DRC and TWU.)

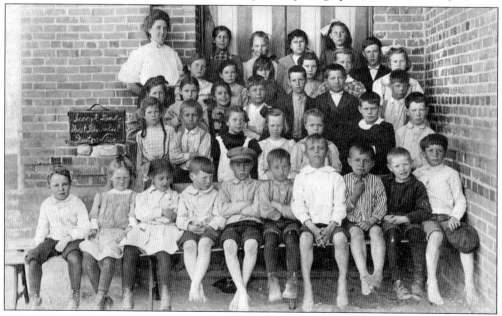

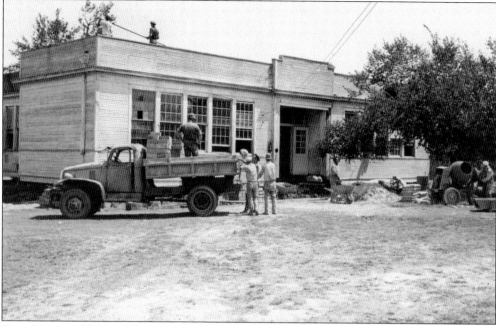

FRED DOUGLAS[S]/FRED MOORE SCHOOL. An African American school was established in Denton as early as 1876. The first three African American teachers were Archie Russel, Joe Blackburn, and Joe Forrest. The Fred Douglas[s] School was located in the Quakertown community in 1910 and burned in 1913. Classes met at St. James A. M. E. Church and the Odd Fellows Hall. A new structure was built on Wye Street and Fred Douglas Moore became principal in 1915. A larger building was erected in 1949 and named Fred Moore School. The high school closed in 1967 and the elementary school in 1969. Pictured above is the Fred Douglas[s] School, which was taken after 1949 when the building was a community center. Principal Charles B. Redd and teacher Alice Alexander are shown to the right in an elementary school classroom of the new addition to the Fred Moore School in 1961. (Both DRC.)

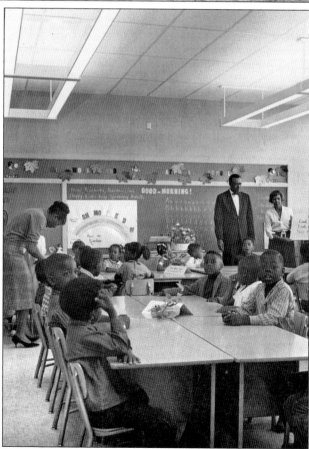

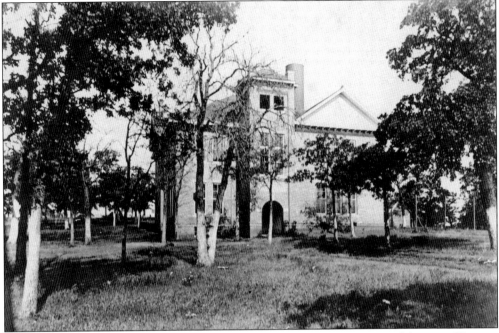

JOHN B. DENTON COLLEGE, 1904. In the spring of 1901, five leading citizens of the city of Denton voted to establish a college. They purchased land on Denton Street and constructed a large brick building. Oliver M. Thurman served as the college's first president. In 1904, the Church of Christ assumed control and renamed the school Southwestern Christian College, which operated from 1904 until 1908. The college moved to Cleburne and then to Abilene and is now Abilene Christian College. Pictured below is the first class of the John B. Denton College with female students in uniforms and mortar boards. (Both DCM.)

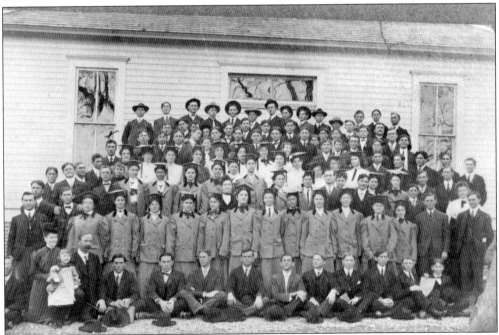

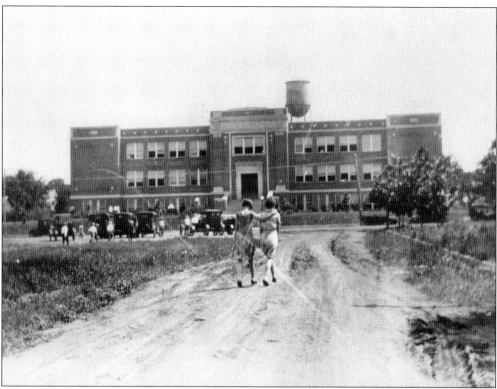

DENTON HIGH SCHOOL. In 1912, the Denton School District purchased the old John B. Denton College campus and moved all high school classes from the Robert E. Lee School. In 1924, this new senior high school opened on the north end of the campus. The building became the junior high school in 1957 when the high school classes moved to Fulton Street. The site became Congress Junior High School in 1968 and Calhoun Middle School in 1982. To the right is a page of the high school students and faculty sponsors who worked on the 1926 yearbook, the *Bronco*. (Both DCM.)

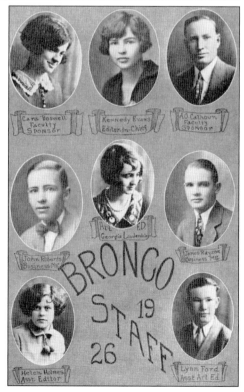

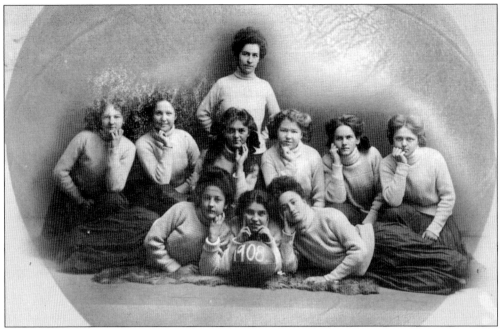

DENTON HIGH SCHOOL GIRLS' BASKETBALL TEAM, 1908. The high school girls' basketball team organized in 1907 and was the only organized sport for females. Pictured in their uniforms of turtleneck sweaters and long skirts are, from left to right, (first row) Katie Bass, Blanch Thomason, Mary Williams; (second row) Nell Bayless, Lucille Blewett, Emma Bell Lipscomb, Susie Davidson, Lula Evers, Maude Zumwalt; (standing) coach Maude Bruce. (DPL.)

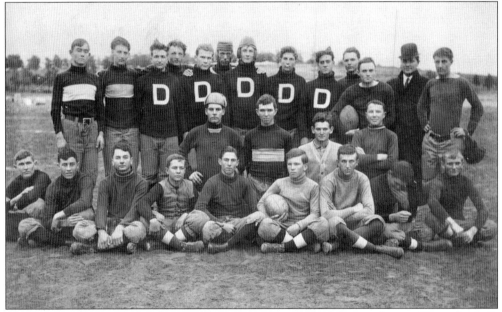

DENTON HIGH SCHOOL FOOTBALL TEAM, 1912. Continuing in a long tradition of Texas football, from 1910 through several seasons, Denton High School fielded one of the strongest high school football teams in the state. Players from the first and second teams are pictured with Prof. R. E. Jackson, who was also the coach (third row, second from the right). (DPL.)

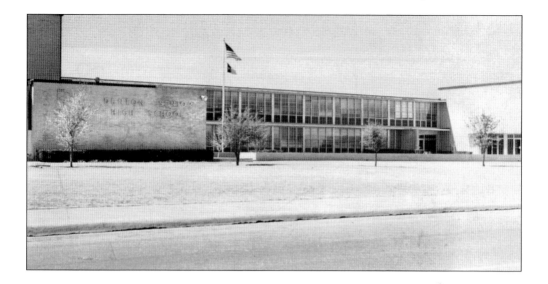

DENTON HIGH SCHOOL. Due to overcrowding at the old high school, land was purchased in 1955 on Fulton Street for a new high school at a cost of $1.5 million. The school opened in September 1957. The first principal was John Guyer, who served until 1966. Air conditioning was not added until 1970. This building continued to be the only high school until 1991 when the Billy Ryan High School opened. Denton High School is known for technological curriculum in teaching career skills. In 2006, the school district opened the Troy and Sarah LaGrone Advanced Technology Complex. (Both DRC.)

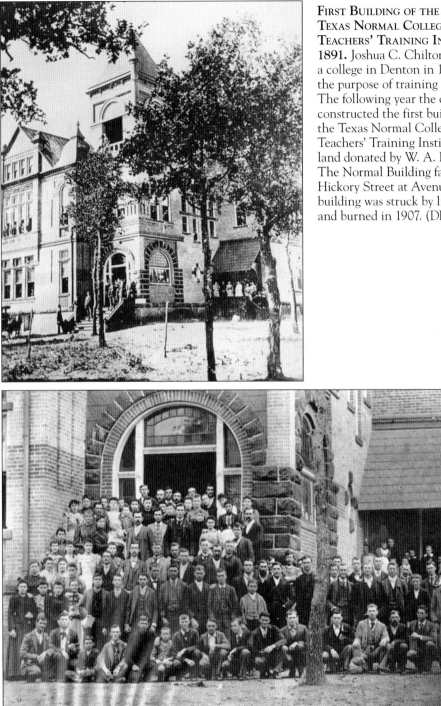

FIRST BUILDING OF THE TEXAS NORMAL COLLEGE AND TEACHERS' TRAINING INSTITUTE, 1891. Joshua C. Chilton opened a college in Denton in 1890 for the purpose of training teachers. The following year the city constructed the first building for the Texas Normal College and Teachers' Training Institute on land donated by W. A. Ponder. The Normal Building faced West Hickory Street at Avenue B. The building was struck by lightning and burned in 1907. (DRC.)

NORTH TEXAS NORMAL COLLEGE STUDENT BODY, 1894. Menter B. Terrill leased the Normal Building from the city to house all preparatory through collegiate-level classes. The name was changed due to a mix-up in state legislation wording, which granted the North Texas Normal College the right to confer state teaching certificates. (DPL.)

FIRST LIBRARY BUILDING, 1913. The first Library Building was completed at an expense of $55,000 and occupied in 1913. It was a three-story structure with a gymnasium on the lower level, the library on an entire floor, and classrooms and meeting rooms on the third level. After a new library opened in 1936, this building became known as the Historical Building, housing a museum. It was renamed Curry Hall in the 1990s. (DRC.)

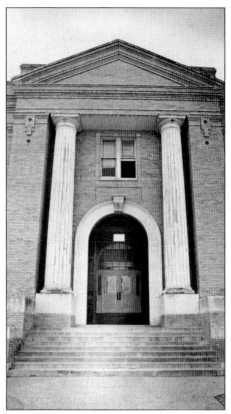

NORTH TEXAS STATE TEACHERS COLLEGE MUSEUM. The museum began in 1925 as a request of the Criddle Society students. The following year, Dr. J. L. Kingsbury, head of the history department, was named curator and space was given in the Library Building. The Texas legislature designated the museum as a State Historical Collection in 1930. It closed in 1986, and the collections were divided between the Courthouse-on-the-Square Museum in Denton and the Layland Museum in Cleburne. (DCM.)

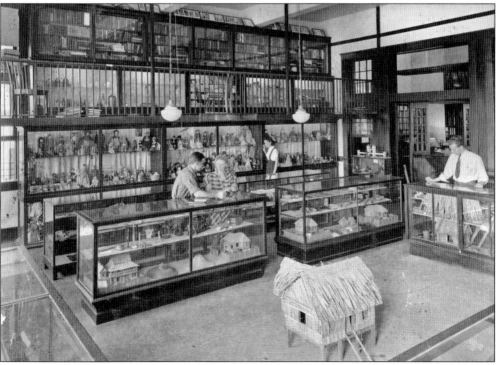

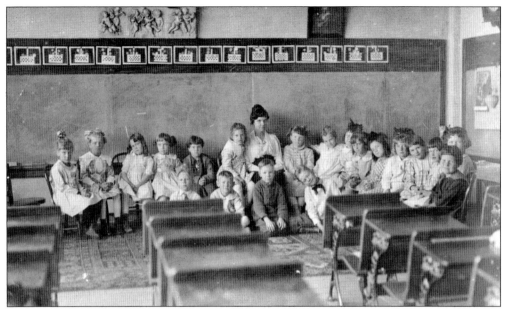

DEMONSTRATION SCHOOL. In 1914, a training school was opened on the North Texas State Normal College campus to train student teachers. The training school was housed in the Education Building in 1919. From 1951 until 1969, the college and Denton public schools jointly operated the training school. This photograph is of Miss Patrick's class at the training school during the 1917–1918 school year. (DCM.)

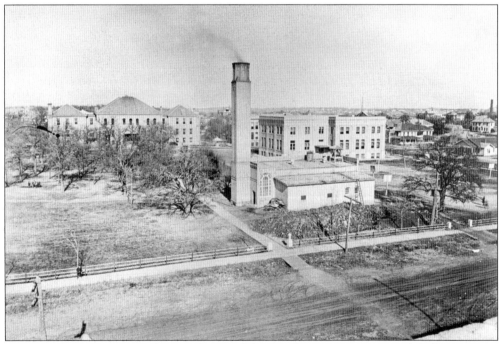

CAMPUS OVERVIEW, 1919. This aerial view of the North Texas State Normal College campus shows the power plant in the center, the Main Building on the left, and the Library Building on the right with a portion of the Science Building visible behind it. (DRC.)

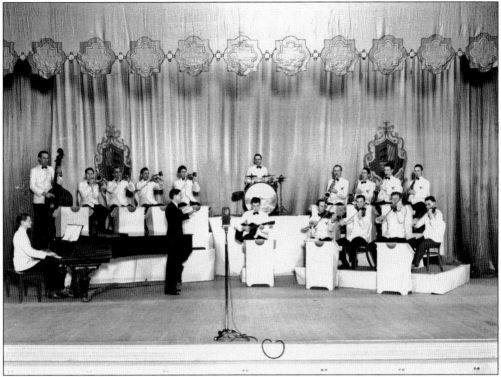

FLOYD 'FESSOR GRAHAM AND THE ACES OF COLLEGELAND BAND. Floyd Graham left his job at Denton High School to become the orchestra conductor at North Texas State Teachers College. He organized the Aces in 1927, who performed weekly at the Saturday Night Stage Shows. The Saturday Night Stage Shows featured future stars such as Ann Sheridan, Joan Blondell, and Nancy Gates. (DPL.)

ONE O'CLOCK LAB BANDS. Gene Hall began the Laboratory Dance Band program in 1947 at North Texas State Teachers College. In 1959, Leon Breeden succeeded Gene Hall as director. Under Breeden, the One O'Clock Lab Band was nominated for two Grammy Awards. Neil Slater became an internationally recognized One O'Clock Lab Band director from 1981 until 2008. This photograph of Breeden and the One O'Clock Lab Band was taken in 1979 at the State Fair of Texas. (DRC.)

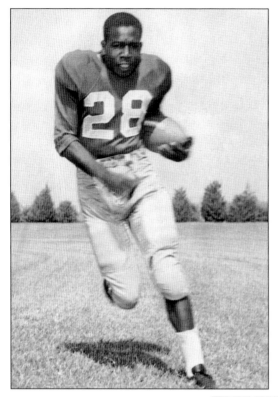

ABNER HAYNES. Racial integration began at North Texas State College in 1956. Abner Haynes was the first African American to play football at North Texas State College from 1956 until 1959, including the All-American team in 1959. He played professional football for the Dallas Texans, Kansas City Chiefs, Denver Broncos, Miami Dolphins, and New York Jets. He was recently named to the Texas Sports Hall of Fame. (DRC.)

CHARLES EDWARD "MEAN JOE" GREENE. All-American tackle Joe Greene played varsity football at North Texas State University from 1966 until 1968. A 10-time All-Pro performer, Greene played defensive tackle for the Super Bowl champion Pittsburgh Steelers. "Mean Joe" retired after 13 seasons with the Steelers in 1982. He was inducted into the National Football League's Hall of Fame in 1987. He served on the University of North Texas Board of Regents from 1983–1987. (DRC.)

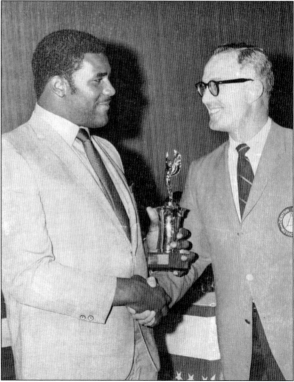

ANNIE WEBB BLANTON. Annie Webb Blanton taught English as part of the first North Texas State Normal College faculty from 1901 until 1918. She became state superintendent of education for Texas in 1918, the first woman to hold an elective office in Texas. She joined the University of Texas faculty in 1920 where she served until her death in 1945. Blanton was a precedent breaker on the political as well as the educational scene. (DCM.)

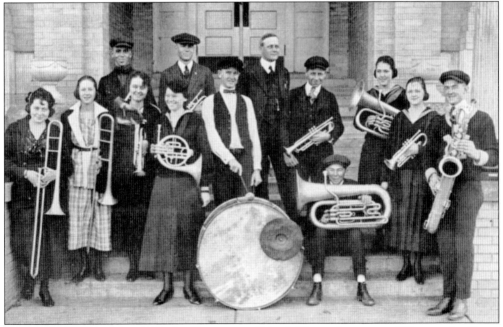

JULIA SMITH. Adopted in 1922, the University of North Texas alma mater, "Glory to the Green and White," was written by Charles Langford and composed by Julia Smith, a member of the North Texas Normal College Band (second from left). She later attended Juilliard and wrote the operetta *Cynthia Parker*, which premiered at the college in 1939. The National Council of Women named her one of the 10 leading composers in 1963. (DCM.)

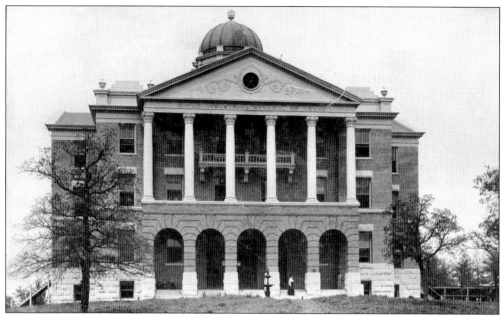

GIRLS' INDUSTRIAL COLLEGE MAIN BUILDING. The Texas legislature established the Girls' Industrial College in 1901; the building's cornerstone was laid in 1903. The adopted motto, "We learn to do by doing," reflected its mission to educate women. Cree T. Work was the school's first president. In 1905, the name changed to the College of Industrial Arts. Other name changes occurred in 1934 to Texas State College for Women and again in 1957 to Texas Woman's University. (DRC.)

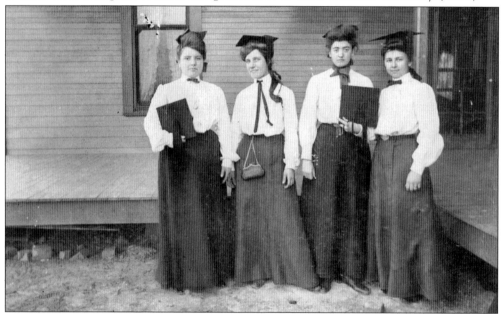

COLLEGE OF INDUSTRIAL ARTS STUDENTS' UNIFORMS. Upon the establishment of the College of Industrial Arts, students were required to wear uniforms of blue serge and a mortar board, thus the campus nickname "Blue Serge Hill." This photograph shows four students in uniform outside Mrs. Ashby's boardinghouse at Sawyer and Locust Streets. A more casual uniform of blue or white chambray was later adopted. The class of 1938 was the last to wear a uniform. (DCM.)

LITTLE CHAPEL-IN-THE-WOODS.
Built in 1939 at a cost of $45,000, the Little Chapel-in-the-Woods was designated one of 20 outstanding architectural projects in Texas. The chapel was designed by noted architect O'Neil Ford, with the assistance of Arch B. Swank and Preston M. Geren, and built by the National Youth Administration. Students under the direction of art professor Dorothy (Toni) LaSelle created the stained-glass windows, brass lighting fixtures, and the woodwork for the pews. Pictured above from left to right are Arch B. Swank, Dorothy LaSelle, and O'Neil Ford. Eleanor Roosevelt dedicated the chapel on November 1, 1939. The most prominent window is the Motherhood Window in the chancel, which is pictured to the right. Eight other windows depict the traditional women's professions of nursing, teaching, science, social service, speech, literature, dance, and music. A rose window greets visitors above the entrance. (Both DRC.)

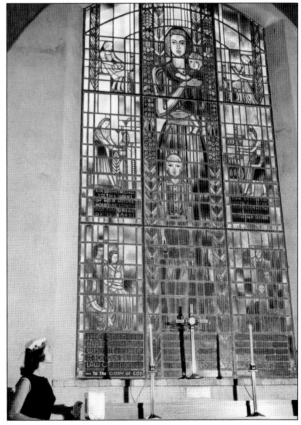

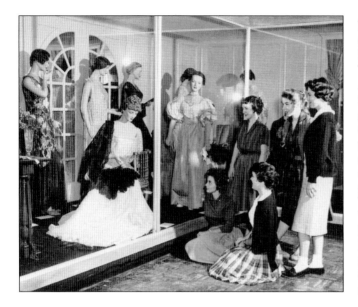

FIRST LADIES OF TEXAS GOWNS. Marion Day Mullins, a member of the Texas Daughters of the American Revolution, started the project of assembling gowns representing wives of Texas governors, the presidents of the Republic of Texas, one vice president, and two presidents. The gowns were presented to Texas State College for Women in 1940 by the Daughters of the American Revolution. The collection represents dresses beginning in 1836 with additions from each new first lady. (DRC.)

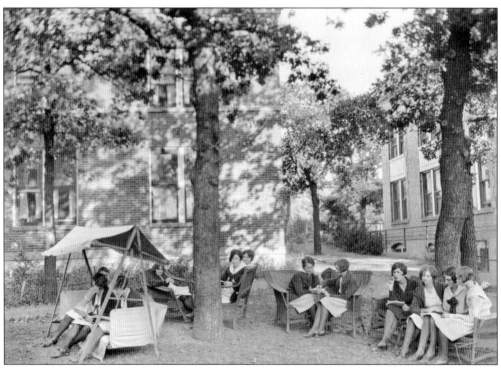

COLLEGE OF INDUSTRIAL ARTS STUDENTS. Although students of the College of Industrial Arts had many organizations and activities to participate in, above all the college promoted an atmosphere "to create a spirit of scholarly endeavor and to maintain a high academic standing." This 1928 photograph shows several students studying under a canopy of trees on campus. (DRC.)

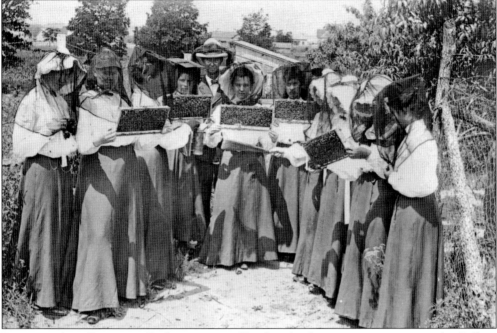

DOMESTIC ARTS PROGRAM. Beekeeping was offered in the domestic arts program at the College of Industrial Arts as part of the general home economics coursework. Intellectual development and vocational skills, as well as practical homemaking skills, were emphasized at the college to prepare women for both home life and the workforce. (TWU.)

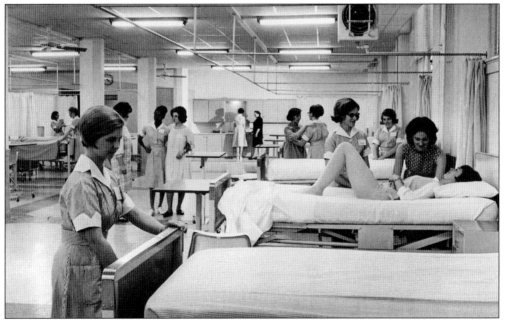

HOME NURSING PROGRAM. The Texas Legislature approved a campus hospital and home nursing program in 1907 at the College of Industrial Arts. The Bachelor of Science in nursing was first offered in 1940. This photograph of nursing students was taken in the early 1950s in the basement of Lowry Hall. (TWU.)

MARGO JONES, "THE TEXAS TORNADO." After receiving her bachelor's and master's degrees from the College of Industrial Arts, Margo Jones launched the American regional theater movement. She is known for her innovative concept of theater-in-the-round and introduced the works of Tennessee Williams, William Inge, and the writing team of Jerome Lawrence and Robert E. Lee. *Stage* magazine identified her as one of 10 outstanding young directors in the country, the only woman to be recognized as such. (DCM.)

MARY EVELYN BLAGG HUEY. Mary Evelyn Huey was the first woman and only alumna president of Texas Woman's University. She was inaugurated in 1977 and served until 1986. She is recognized for inspiring international opportunities for students in Iran, Mexico, and Japan. Texas Woman's University retained its status as an independent state university under her leadership. In 1986, the university dedicated a new library in honor of Dr. Huey. (DRC.)

Five

PEOPLE AND PLACES
THE SOUL OF THE CITY

OTIS GREENWOOD WELCH (1836–1880). Otis G. Welch was a Yale-graduated lawyer and a teacher in Illinois and Virginia. He was legal advisor in the establishment of the city of Denton, assisted by C. C. Lacy and William Woodruff as surveyors. Welch later set up a law practice with Joseph A. Carroll on the square. He was known as the "Father of Denton." (IOOF.)

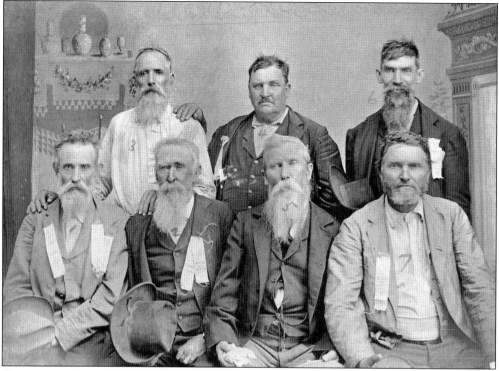

CONFEDERATE VETERANS. Capt. Felix McKittrick organized Company G, 18th Texas Cavalry, Confederate States of America in February 1862. Denton County men who fought in the Civil War are, from left to right, (seated) 1st Lt. R. H. Hopkins, 2nd Lt. W. B. Brown, Pvt. C. A. Williams, and Pvt. Spencer Graham; (standing) Pvt. John Martin, Pvt. W. O. Medlin, and Pvt. Boone Daugherty. (DPL.)

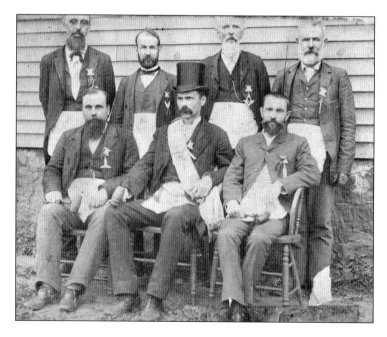

STANFIELD MASONIC LODGE NO. 217. The first lodge to be organized in Denton was the Stanfield Masonic Lodge No. 217, A. F. & A. M., chartered on June 22, 1858. Members built a two-story masonic hall on South Elm Street in 1859. These officers, posing in 1888 from left to right, are J. W. Cook, S. M. Bradley (worshipful master), and C. H. Clements; (standing) J. R. McCormick, W. H. Sprawls, W. R. Dudley, and W. F. Egan. (DPL.)

CHARLES ALEXANDER WILLIAMS (1832–1922). C. A. Williams moved to Denton County from Collin County in 1852. He served as Denton County sheriff from 1856–1858 and from 1866–1867. As sheriff, he auctioned off town lots for the city. He was one of the first men to enlist in the Confederate army. He operated the Williams Store, a general mercantile business on the square. Upon his death, all businesses in the city closed in his honor. (DPL.)

JUDGE JOSEPH A. CARROLL (1832–1891). Joseph A. Carroll served in the Confederate army in Otis Welch's Company E, First Chickasaw and Choctaw Mounted Rifles. In 1876, he was elected 16th District Court judge. He served as mayor of the city and was an organizer and president of Exchange National Bank. He was a member of a group of businessmen known as the "Syndicate," who were responsible for organizing the Texas Normal College in 1890. (DCM.)

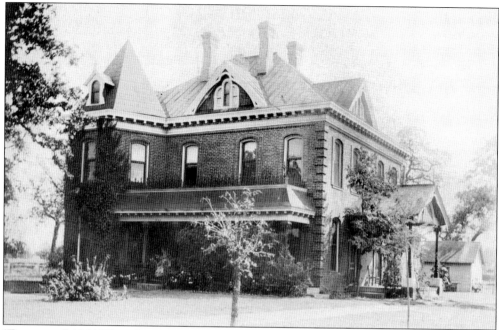

"BOSCOBEL," 1801 WEST OAK STREET. W. C. Wright built his home—Boscobel—in 1892 at a cost of $13,000. The house sat on a 7-acre lot and featured 10 fireplaces. He also had a 16,000-acre horse ranch in Bolivar, one of the largest in the southwest. Boscobel was torn down in 1942. (DPL.)

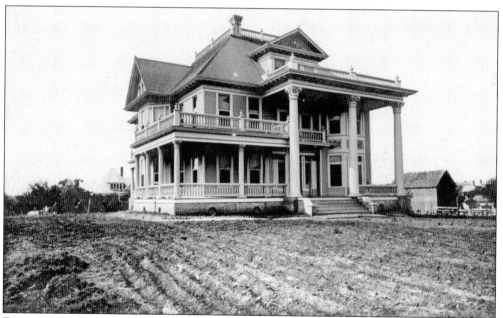

EVERS HOME, 1035 WEST OAK STREET. This neoclassic home was built in 1903 for Mary and Robert Evers, a hardware merchant. The third story held a smoker and gymnasium. The home was one of the few with a basement. The house was badly damaged by fire in 1977 and later restored by Dolph Evers under the direction of local architect and preservationist Isabel Mount Miller. (DCM.)

DENTON ARIEL CLUB, 1957. The Denton Ariel Club was organized in 1891 and was named for Ariel—the city where David dwelt (Isaiah 29:1). The club motto, "Knowledge is the treasure of which study is the key," reflects the social and intellectual purpose of the departments of the club. This photograph, taken in Marquis Hall, is of members dressed for the Denton centennial. (DRC.)

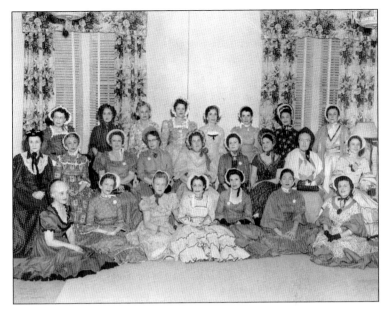

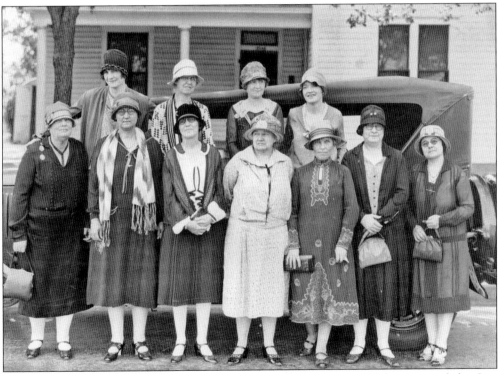

CITY FEDERATION OF WOMEN'S CLUBS. The Ariel and Shakespeare Clubs organized the City Federation of Women's Clubs in April 1913 to improve education, sanitation, and beautification in the city. This picture, taken in 1927 on a trip to Lake Trinidad, Texas, shows members, from left to right, (first row) Lee Williams, Gertrude West, Nettie Edwards, Fannie Blanks, Maggie Yancy, Ettie Woods, and Mrs. Fisher (from Dallas); (second row), Inez Curtis, Flora Garrison, Nancy Turner, and Iris May. (DPL.)

BOYS' CORN CLUB. District agent William Ganzer of the Federal Department of Agriculture organized the Denton County Boys' Corn Growers' Clubs in 1909 to encourage good farming techniques. The county boasted one of the largest clubs in the state with more than 300 boys. This photograph shows the club at a meeting held in Denton in 1910. The clubs were the predecessors to 4-H Clubs. (DCM.)

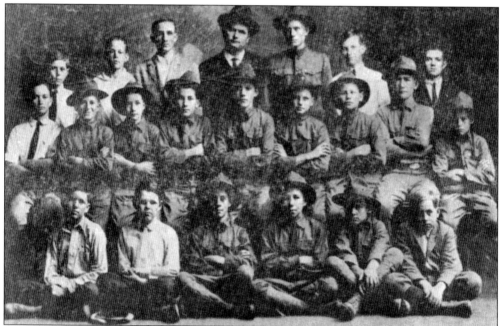

BOY SCOUTS. W. A. Combest, principal of the North Ward School, organized Boy Scout Troop 1 in 1914. By 1917, Troop 2 was organized under Stanley Musgrave, and in 1918 Wardo Fouts became scoutmaster of Troop 3. "Hills and Hollows," a campsite for the scout groups, was dedicated in 1931. Today Denton boasts more than 29 scout troops. (DCM.)

DENTON CIVIC BOY CHOIR. The Denton Civic Boy Choir, drawing its entire talent from the city of Denton, started in 1946 with 37 members under the direction of George Bragg. He organized the choir while a North Texas State Teachers College student. In 1951, the choir added members from Fort Worth. The choir sang to raise funds for charitable causes and is shown at right singing for the Christmas Seal Drive. The Denton Civic Boy Choir School was founded in 1955 (now the Selwyn School); one year later, the choir officially became known as the Texas Boys Choir of Denton. In 1957, the choir moved to Fort Worth and assumed the name Texas Boys Choir of Fort Worth. That was also the year the choir made its first national television appearance on the Pat Boone Show, seen below. The Texas Boys Choir still exists in Fort Worth. (DRC.)

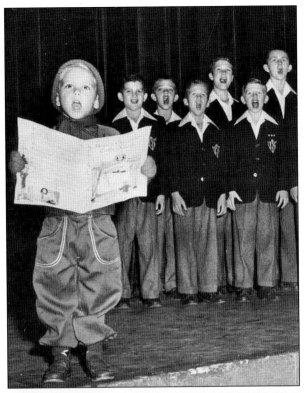

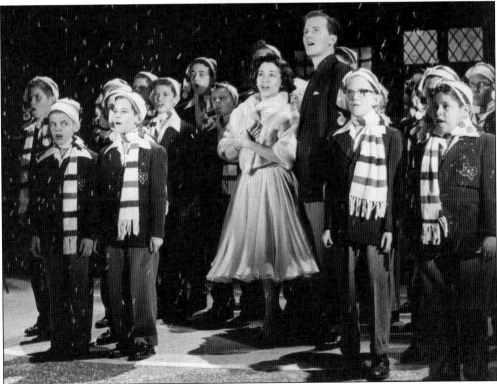

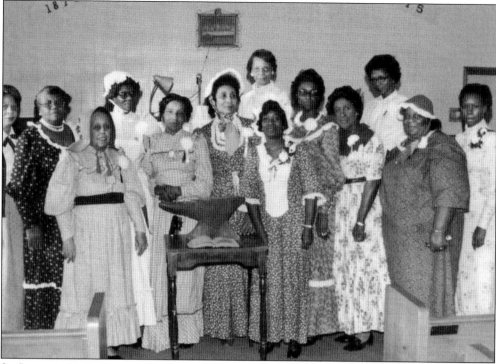

St. James A. M. E. Church. Established in 1876 in Freedman Town, St. James African Methodist Episcopal Church was the first African American church in Denton. The church moved to Oakland Avenue in Quakertown. School was held in the church after the Fred Douglas[s] School burned. In 1922, the congregation moved to Oak and Crawford Streets in Solomon Hill. The current church was built in 1962. This 1975 photograph is of the ladies of the church. (DCM.)

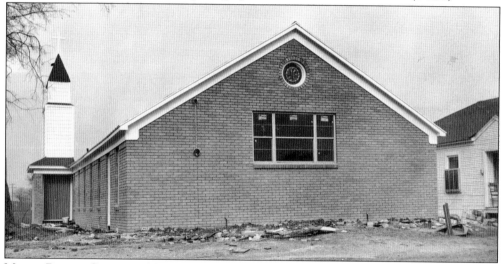

Mount Pilgrim Christian Methodist Episcopal Church. Organized in 1880, the first meetings of Mount Pilgrim Church were held on Hodge's Lot on Allen Street under the leadership of Shepherd Middleton, a circuit rider. The first church was built in 1910. The old church was moved slightly north and a second building, pictured here, was completed in 1958 at 339 Robertson Street. (DRC.)

PLEASANT GROVE MISSIONARY BAPTIST CHURCH. The Pleasant Grove congregation first gathered under a brush arbor near Pecan Creek about 1884. The first church was built at Holt Street. In March 1923, the church purchased the present site from A. L. Miles and moved the old building, shown in photograph, including the original bell, to South Wood Street. A new building was constructed in 1950. (DCM.)

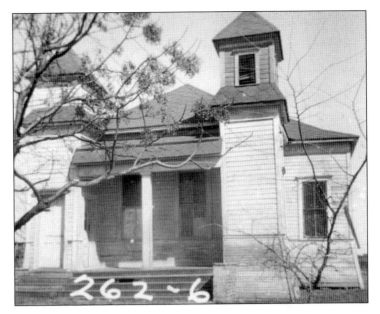

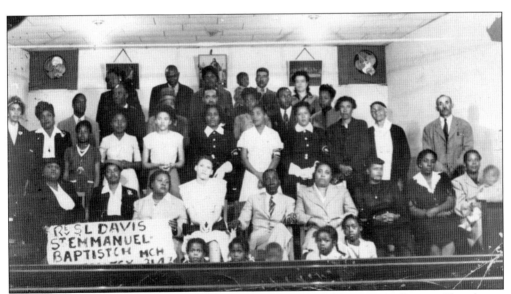

ST. EMMANUEL MISSIONARY BAPTIST CHURCH. St. Emmanuel Missionary Baptist Church was organized 1906 as Second Baptist Church at Sanders and Oakland Streets in Quakertown. In 1923, the congregation moved from its Quakertown site to the current location at 509 Lakey Street. The church pastor, Rev. J. A. Ayers, was a vocal opponent about the relocation. This photograph was taken of members of the St. Emmanuel Missionary Baptist Church congregation during the pastorship of Rev. S. L. Davis. (Courtesy of Kim Smith.)

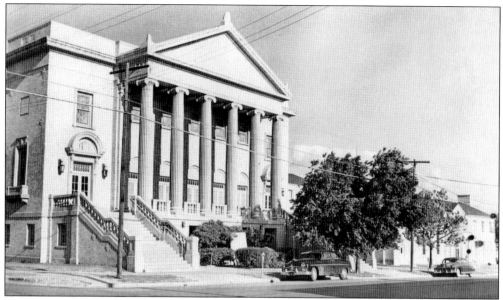

FIRST UNITED METHODIST CHURCH. William F. Bates, a circuit rider, was said to have organized the Methodist church in Denton in 1857. First United Methodist Church's earliest services were held in the courthouse and the Masonic Hall until a one-room, white-frame church was built facing South Locust Street in 1872. A new structure, shown in this photograph, was built and the congregation moved into the new building in 1925. (DRC.)

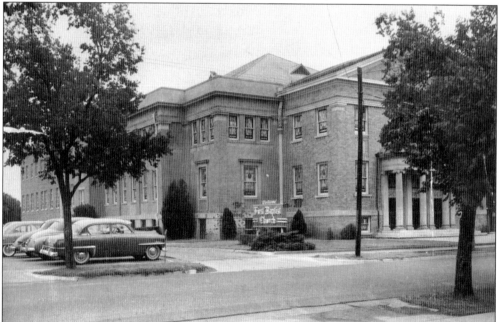

FIRST BAPTIST CHURCH. First Baptist Church was organized in 1858 with 12 members. H. S. Holdman was the pastor. By 1876, the first church home was built at the corner of West Hickory and Cedar Streets. The church moved to 404 West Oak Street, the pictured location, in 1918. In 1961, the congregation purchased a 13-acre lot at 1100 Malone Street and erected the current building. (DRC.)

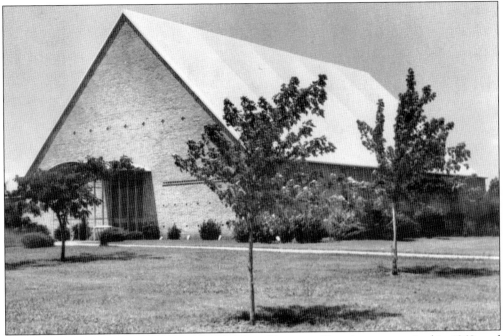

FIRST CHRISTIAN CHURCH OF DENTON. The First Christian Church was organized in 1868, and the first church was built in 1876. A brick building, constructed in 1904, remained the church home until 1939. When that building was condemned, a frame church building was constructed. The current building, designed by O'Neil Ford and Howard Wong, was completed in 1959. The roof was designed to resemble hands folded and lifted in prayer. (DRC.)

IMMACULATE CONCEPTION CATHOLIC CHURCH. Immaculate Conception Catholic Church began as a mission about 1890 and held services in the second floor of a barn until a church building, pictured here, was erected between 1893 and 1894. Fr. F. X. Meilinger was the first priest. A new brick structure was constructed in 1956. The church established a hospital ministry and outreach program to provide for the needy. (DRC.)

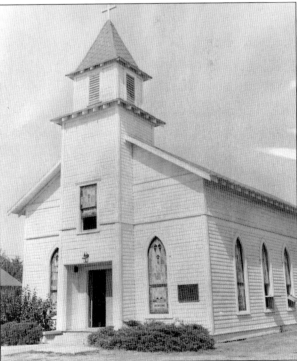

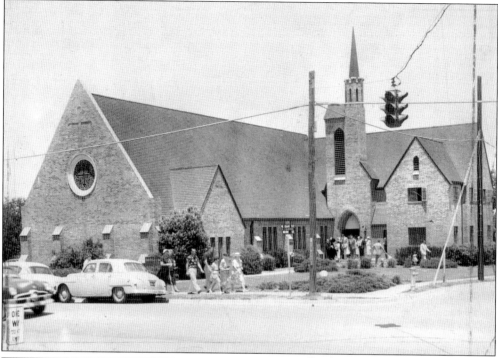

St. Andrew Presbyterian Church. St. Andrew Presbyterian Church was established as the Cumberland Presbyterian Church in 1862. The congregation changed names four times in its nearly 150-year history. The first services in the church building, pictured here at West Oak and Bolivar Streets, were in 1942. (DRC.)

Cumberland Presbyterian Children's Home. Established by the Cumberland Presbyterian denomination, the children's home was originally chartered in Kentucky in 1904. The Cumberland Presbyterian Children's Home moved to Denton in 1931. Since the building of Old Main in 1939, the children's home has provided residential care for parents and their children. Celebrating Christmas with a tree and presents is a tradition at the children's home as seen in this 1981 photograph. (DRC.)

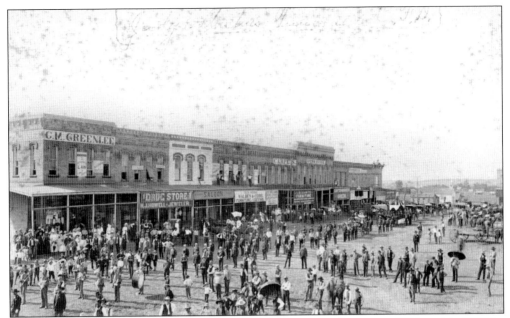

WILLIAM J. AUSTIN (1856–1888). William J. Austin came to Denton in 1874, and in 1880 he became Denton's first fire chief. He was elected president of the Texas State Firemen's Association in 1884. This photograph of Chief Austin's funeral, led by a brass band, occurred on September 8, 1888. Fire department members from Denton and across the state marched in his funeral procession. (DPL.)

EDNA TRIGG (1868–1946). Edna Trigg was appointed the home demonstration agent for Denton County in 1916, the first agent appointed in the state. She organized Tomato Clubs to teach girls proper food production, canning, and nutrition techniques. Under her direction, Denton County became one of the top Texas counties in the amount of food canned annually. (DRC.)

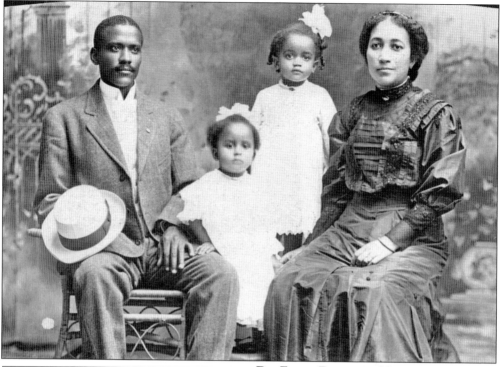

DR. EDWIN DONERSON MOTEN FAMILY.
Edwin D. Moten, an early resident of
Quakertown, resided in Denton from
1907 until 1920. He was the only African
American physician in Denton County
during that time. In 1920, he and his family
moved to Indianapolis, Indiana. Pictured
are, from left to right, Edwin, daughters
Carrie Annetta and Myrtle Bell, and wife,
Susie Annetta Whitlock Moten. This
photograph was taken before the birth of
their son Edwin Donerson Jr. (DCM.)

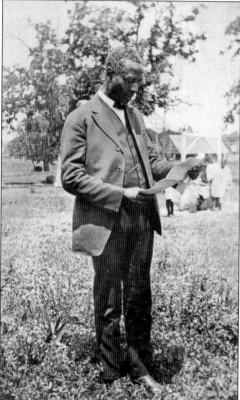

FRED DOUGLAS MOORE (1875–1953). Fred
Douglas Moore was an educational leader
for nearly 40 years. The son of a former slave
whose father left before his birth, Fred was
adopted by his stepfather, Henry Lucien
Moore. Before becoming principal of Fred
Douglas[s] School, he operated a barber
shop and organized a band. Fred Moore Park
and Fred Moore School are named in his
honor. He and his wife, Sadie, had daughters
Lela, Alice, Hazel, and Daisy. (DCM.)

VILLANUEVA AND RAMIREZ FAMILIES. The 1920 census listed four Hispanic families living in the city of Denton. Antonio (Tony) Villanueva came to Denton during that decade and worked for the Menchaca family restaurant and hot tamale stand on the square. The photograph to the right features Marguerita (wife), Tony, and two of their eight children, Ramona and Antonio. Clemente Ramirez and his wife, Pearl (Garza), had six children: John, Jovita, Tonnie, Amelia, Rosita, and Victoria. The family moved to Denton in 1957. Clemente Ramirez worked 35 years for the Texas and Pacific Railroad. In the photograph below, Ramirez (far left) is shown at his daughter Rosita's wedding to James Ramirez (far right). (Both DCM.)

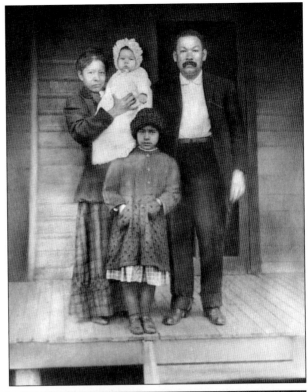

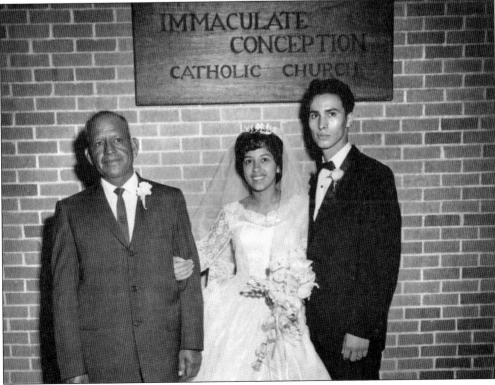

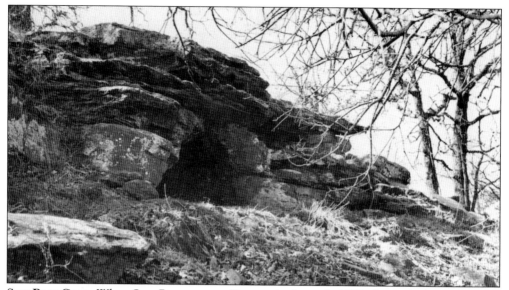

SAM BASS CAVE. When Sam Bass came to Denton in the early 1870s, he worked in the wagon yard of the Lacy Hotel and for Sheriff W. F. Egan. Bass became known for his racehorse, the Denton Mare. His career escalated to robbing stagecoaches, passenger trains, and banks. He was shot during a bank robbery and died on his birthday, July 21, 1878. Bass allegedly hid out in this cave on Pilot Knob. (DPL.)

MARTIN-STOREY GANG. W. A. Martin, Nathan A. Storey, and Yancey Storey were bank robbers and car thieves. After a shoot-out on the square in 1925, Martin and Yancey Storey were arrested. While they were released on bail, W. A. Martin shot Deputy Sheriff Robert B. Parsons, who was investigating the gang's car thefts. Martin served 20 years for Parsons's murder. (DCM.)

SAMUEL TANKERSLEY WILLIAMS (1897–1984). Denton-born Lt. Gen. Samuel T. Williams earned the nickname of "Hanging Sam" for his somber command and disciplinary standards. Lieutenant General Williams began his nearly 45 years of service in 1916 with the Texas Militia and served in World War I, World War II, the Korean War, and the Vietnam War. He was awarded every army decoration for valor except the Medal of Honor. (Courtesy of Richard Harris.)

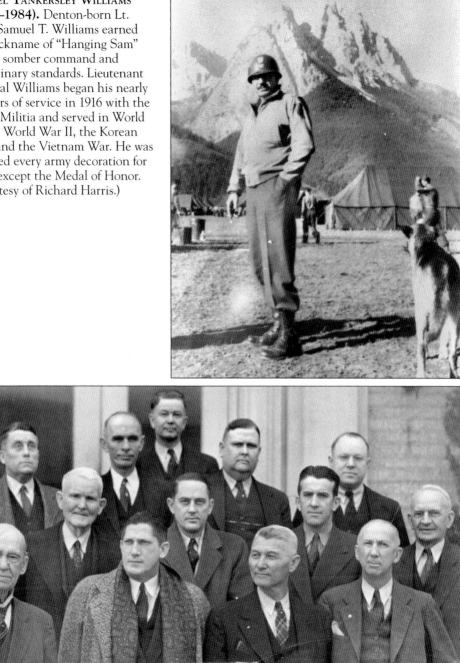

DENTON CHAMBER OF COMMERCE. Denton's first chamber of commerce, the Commercial Club, met in the Wright Opera House in 1909. This 1937 photograph is of some of the chamber's early past presidents. They are, from left to right, (first row) Alvin C. Owsley, Ben Ivey, Jack Gray, and Abney Ivey; (second row) J. Newton Rayzor, J. Holford Russell, William Hicks, and William Long; (third row) Lawrence McDonald, Robert Barns, Oron Bell, and Floyd Brooks; (fourth row) Otis Fowler. (DRC.)

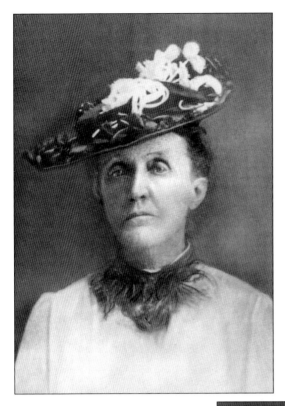

DR. LOUISA OWSLEY (1830–1903). Dr. Louisa Owsley, a self-taught homeopathic doctor, is known as the first female physician in Denton. She and her husband, Henry, a conventional doctor, came to Denton in 1872. She is credited with delivering more babies than any of her male counterparts. Because of their differing medical views, she supposedly only allowed her husband to do one task for her—harness her horse and buggy for her daily rounds. (DPL.)

ALVIN MANSFIELD OWSLEY (1888–1967). Alvin M. Owsley, son of Alvin Clark Owsley and Sallie Blount Owsley, was one of Denton's most distinguished citizens. His career spans from diplomatic assignments in the Irish Free State, Denmark, and Romania to founder and national commander of the American Legion. The inscription on this photograph reads, "To Alvin Boney, my nephew—of whom I am justly proud. Alvin M. Owsley." (DCM.)

JESSE NEWTON RAYZOR (1895–1970). Denton-born J. Newton Rayzor, lawyer and philanthropist, gave dozens of gifts to his hometown, including the land for Denia Park (named after his wife), Selwyn School (named after his daughter), the Kiwanis children's clinic, three schools (including one named in his honor), and the carillon bells for First Baptist Church. The photograph to the right is of Rayzor (left) being presented with a Junior Chamber of Commerce award by chamber president Tom Harpool. Rayzor built a stately Williamsburg Colonial summer home—Hill View—on his ranch at the intersection of Bonnie Brae and Scripture Streets, where he raised award-winning Angus cattle and registered Texas Longhorns. The image below is a conceptual rendering of the house on the hill. (Both DRC.)

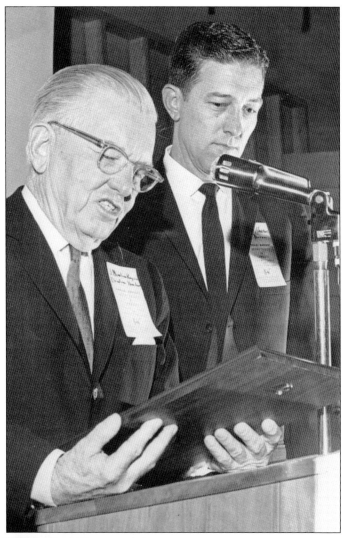

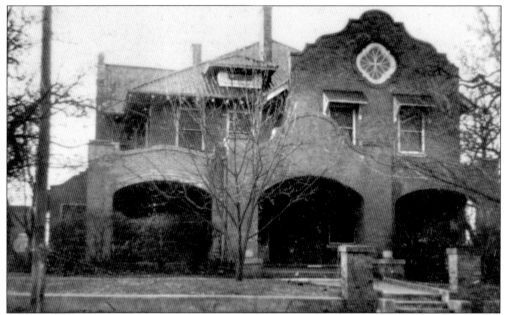

SCRIPTURE HOUSE, 819 WEST OAK STREET. Annie and Robert C. Scripture, a prominent grocer, built a brick Victorian-Italianate two-story home in 1885. The home was sold to Robert Hann, a merchant and civic leader. In 1905, the house was purchased by B. H. Deavenport for $5,000. He doubled the size of the house and added the mission-style facade. Ben Ivey Sr. made further changes in 1946. (DCM.)

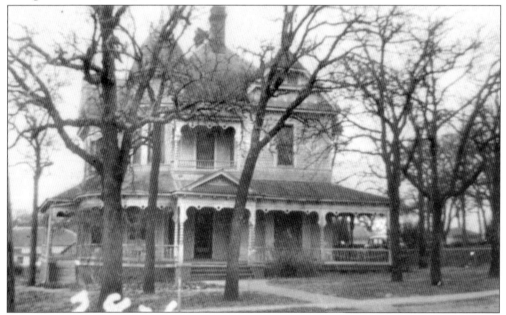

LOMAX HOUSE, 723 WEST OAK STREET. This Queen Anne Victorian was built in 1898 for Otis T. Graham. In 1911, R. P. Lomax and his wife, Lizzie, purchased the home. Their children, Elizabeth and R. H. Lomax, grew up in the house; Elizabeth lived in the house for 69 years. The house had seven fireplaces, each with different architectural styles, a round turret on the second floor, and a semicircular stained-glass window. (DCM.)

BAYLESS-SELBY HOUSE. Samuel Bayless and his wife, Mary, purchased a two-room farmhouse on Myrtle Street in 1884. Bayless added the second story of the house in 1898. He died in 1919, and Mrs. Bayless sold the property to a neighboring nurseryman, R. L. Selby Sr. The Selby family retained ownership of the house until 1970. The house moved to the Historical Park of Denton County in 1998 and opened as a museum. (DRC.)

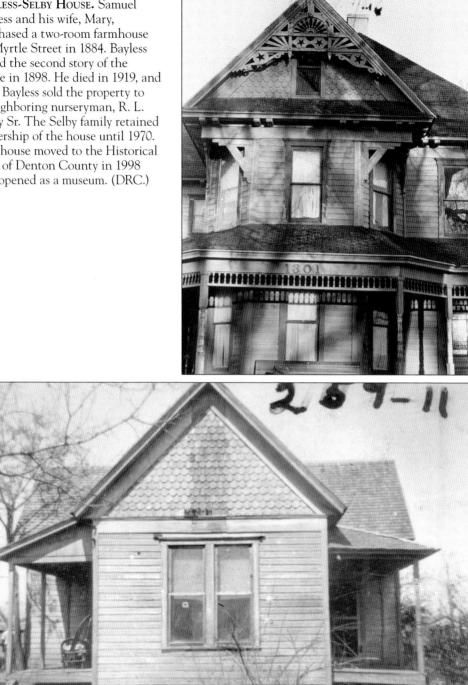

QUAKERTOWN HOUSE. Built in 1904 in the African American community of Quakertown, this house was purchased by C. Ross Hembry in 1919. He sold the land to the city in 1922 and moved the structure to Solomon Hill when the citizens of Denton voted to make the area a park and remove the neighborhood. In 2004, the house moved to the Historical Park of Denton County and was dedicated as the Denton County African American Museum. (DCM.)

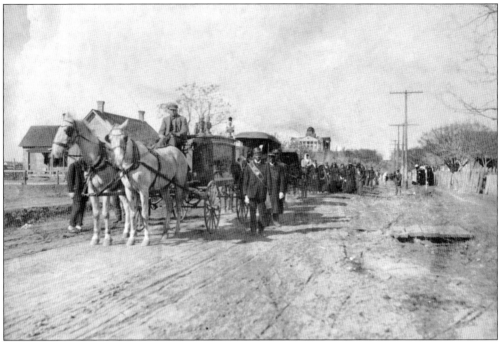

ROSETTA CRAWFORD FUNERAL. Rosetta Hinkle Williams Crawford died on January 10, 1910. This photograph depicts her funeral procession down Bell Avenue from her home at the corner of Withers and Bell Streets in Quakertown to the Oakwood Cemetery. (Courtesy of Erma Peace.)

OAKWOOD CEMETERY. Hiram Cisco offered the city an acre of land southeast of the square in 1857 to begin a city cemetery. The name changed to Oakwood Cemetery in 1931. Several of Denton's prominent citizens are buried at Oakwood Cemetery. This was the only cemetery available for the burials of African American residents. (DRC.)

INDEPENDENT ORDER OF ODD FELLOWS CEMETERY. Denton Lodge No. 82, Independent Order of Odd Fellows was instituted in 1859. Original charter members included leading citizens Otis G. Welch, Joseph A. Carroll, Hugh McKenzie, John S. Chisum, James Smoot, C. A. Williams, and S. A. Venters. A Rebekah Lodge was chartered in 1870. The Independent Order of Odd Fellows Cemetery was established in 1860 when James Smoot, a Denton merchant, donated the tract of land. (DRC.)

ROSELAWN MEMORIAL PARK. In 1926, a new burial ground was opened southwest of Denton. This privately owned and operated cemetery comprised of 80 acres, including the Old Dalton Cemetery, is known as Roselawn Memorial Park. Among the noted burials are championship golfer Byron Nelson and Congressman Ray Roberts. (Courtesy of Roselawn Memorial Park.)

JOAN BLONDELL (1906–1979). Joan Blondell, whose birth name was Rosebud, was born in Denton. She was named Miss Dallas in 1926 and attended the North Texas State Teachers College in 1927, performing in the Saturday Night Stage Shows. She left for Hollywood in 1929 to begin a career in movies and to star in such films as *The Gold Diggers of 1933*, *A Tree Grows in Brooklyn* (1945), and *The Cincinnati Kid* (1965). (UNT.)

ANN SHERIDAN (1915–1967). Denton native Ann (Clara Lou) Sheridan performed in the Saturday Night Stage Shows while attending the North Texas State Teachers College from 1932 to 1933. Her selection in a beauty contest resulted in a Hollywood contract in 1933. She was tagged as Warner Brothers' "Oomph Girl" and enjoyed success in the 1940s. The photograph inscription reads, "To Bub–! You're darn tootin'. I know you kid! Best of luck–will see you some day–As ever–Loudy 1936." (DPL.)

PHYLLIS GEORGE, MISS AMERICA 1971.
Phyllis George, born in Denton, was
Miss America of 1971. She attended
North Texas State University. Her career
included cohosting CBS's *NFL Today*,
founding her own business Chicken by
George, serving as Kentucky's first lady,
and authoring numerous inspirational
books and books promoting Kentucky
crafts. This photograph shows Miss
America Phyllis George on a USO tour
with a Vietnamese child, Miss Iowa, and
an unidentified serviceman. (DRC.)

SHIRLEY COTHRAN, MISS AMERICA 1975.
Shirley Cothran graduated from North
Texas State University and received her
doctorate from Texas Woman's University
in Early Childhood Education and Family
Counseling. This photograph shows her
riding in a celebratory parade through
her hometown of Denton after being
crowned Miss America in 1975. (DRC.)

EUGENE CONLEY. Eugene Conley was artist-in-residence of the North Texas State University music faculty from 1960 until 1978. Prior to arriving in Denton, Conley performed as one of the leading tenors of the Metropolitan Opera and sang at La Scala in Milan. He performed at Eisenhower's inauguration in 1953. This picture shows Conley looking at the program he presented with Jack Roberts, a renowned pianist, at a benefit concert for the Denton County March of Dimes. (DRC.)

ISABEL AND SILVIO SCIONTI. The "irreproachable and irrepressible Sciontis" were internationally famous two-piano concert pianists who performed in music centers in Europe, Mexico, and the United States from 1935 until 1942. Silvio Scionti taught at North Texas State University from 1942 until 1953 while his wife, Isabel, opened a private piano studio. Their legacy continues with the students who won national and international prizes and became luminaries in the music world. (UNT.)

ISABEL MOUNT MILLER. The best description of the contributions of Isabel Mount Miller was given by her daughter Abigail, who said, "[my mother's] Greatest service to the community [of Denton] was in the body of work that Mount-Miller Architects produced—concrete demonstrations that beautiful, functional homes could be had for any neighborhood and virtually any budget—and in the preservation and restoration of the historical structures of the city." Mount Miller partnered with her husband, Tom Polk Miller, in the architectural firm. The Denton Unitarian Universalist Fellowship, shown in the photograph above, was an example of the Mount-Miller firm's work. Isabel Mount Miller was a hands-on restoration specialist, as shown in the photograph at right of her working on the mantel of the Evers house after a fire nearly destroyed it in 1977. (Above, courtesy of Abigail Miller; at right, DRC.)

PAT BOONE. Pat Boone came to Denton in 1955 to study music at North Texas State University. He sang with Graham's Aces of Collegeland, worked for radio station WBAP, and preached at Slidell Church of Christ. His first hit was "Two Hearts, Two Kisses" in 1955. After leaving Denton in 1956, he continued a singing and movie career. This photograph was taken in 1961 while Boone was relaxing in Denton during the filming of *State Fair*. (DRC.)

BRAVE COMBO. This two-time Grammy Award–winning Denton group is the World's First Nuclear Polka Band. Pictured are the original band members, from left to right, Tim Walsh (woodwinds), Lyle Atkinson (electric bass), Carl Finch (keyboardist), and Dave Cameron (drums). Finch and Walsh met while playing for North Texas State University dance classes and Brave Combo was formed the following year in 1979. (DRC.)

Six

SPECIAL EVENTS
THE SPIRIT OF THE CITY

ARMISTICE DAY, 1918.
When news of the
signing of the armistice
reached Denton, Mayor
Beyette declared the day
a holiday and asked that
all public schools, colleges,
and businesses close in
celebration. More than 2,000
citizens paraded around
the square. Fireworks were
set off from the courthouse
to celebrate the end of
World War I—November
11, 1918. (DPL.)

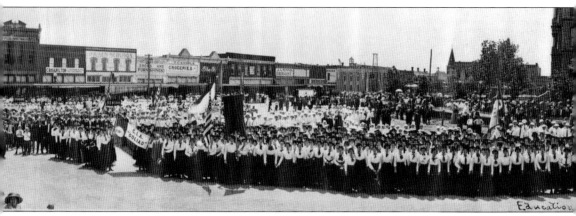

EDUCATIONAL RALLY DAY, 1913. Education has been an important part in the history of Denton since its founding in 1857. On May 5, 1913, Denton staged an educational rally day and parade that ended on the downtown square. Approximately 2,500 students and teachers from the

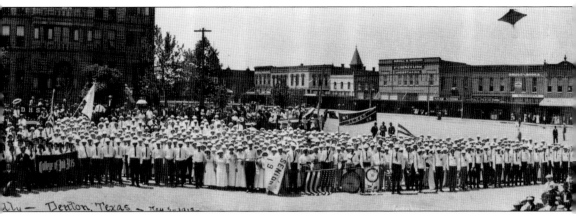

College of Industrial Arts, North Texas Normal College, and four public schools participated in the festivities. This was the first time the citizens of the city realized the magnitude and impact that students had on this "town and gown" community. (DCM.)

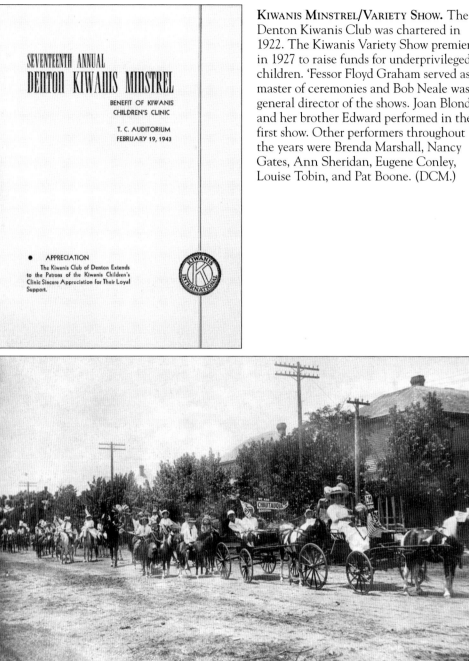

SEVENTEENTH ANNUAL
DENTON KIWANIS MINSTREL
BENEFIT OF KIWANIS
CHILDREN'S CLINIC

T. C. AUDITORIUM
FEBRUARY 19, 1943

• APPRECIATION
The Kiwanis Club of Denton Extends
to the Patrons of the Kiwanis Children's
Clinic Sincere Appreciation for Their Loyal
Support.

KIWANIS MINSTREL/VARIETY SHOW. The Denton Kiwanis Club was chartered in 1922. The Kiwanis Variety Show premiered in 1927 to raise funds for underprivileged children. 'Fessor Floyd Graham served as master of ceremonies and Bob Neale was general director of the shows. Joan Blondell and her brother Edward performed in the first show. Other performers throughout the years were Brenda Marshall, Nancy Gates, Ann Sheridan, Eugene Conley, Louise Tobin, and Pat Boone. (DCM.)

CHAUTAUQUA MOVEMENT. From about 1894, each year the Denton Chautauqua Association contracted a weeklong series of musicians, lecturers, magicians, and other entertainers to perform under a tent. The Chautauqua Society continued to provide cultural entertainment to Denton citizens until it was abandoned in 1920. Effie Williams rides in the lead cart behind her Shetland pony in this 1910 photograph. Alex Williams is driving the second cart. (DPL.)

BASEBALL AND SOFTBALL IN DENTON. Amateur baseball teams formed after soldiers returned from World War II. Under the leadership of H. M. Pitner and manager Claude Linville, the Denton Bears played against other local teams until the early 1950s as part of the Brazos-Trinity Baseball League. The team sponsor was Normile Service Station. A. L. "Cotton" Nix is shown to the right wearing his Denton Bears uniform. The Denton Odd Fellows lodge sponsored a softball team, seen below. Among the 1938 championship team players are Virgil C. Adams (front row, far left) and his son V. C. Adams (batboy). (Right, DCM; below, courtesy of the family of V. C. Adams.)

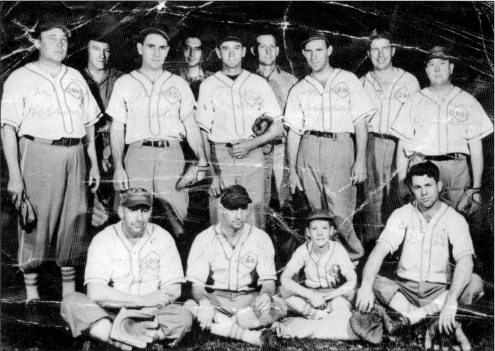

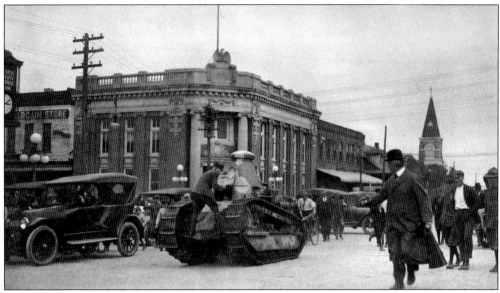

CELEBRATING THE END OF WORLD WAR I. Denton celebrated the return of its soldiers with parades and fireworks. The above photograph shows a military tank in front of the Exchange National Bank Building on the southeast corner of the square. In the photograph to the left, spectators watch a parade along Hickory Street near the recently installed Confederate Soldier Monument. (Above, DCM; at left, DRC.)

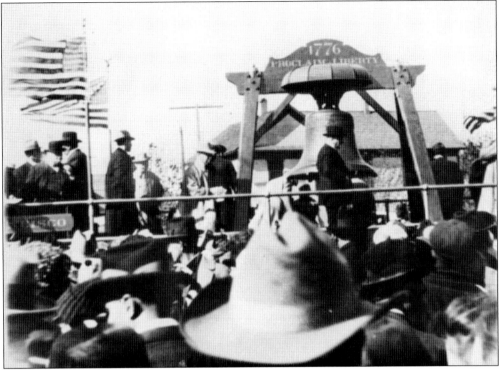

LIBERTY BELL COMES TO DENTON. The Liberty Bell made a five-minute stopover in Denton on November 18, 1915, on its cross-country tour from the Panama-Pacific Exposition in San Francisco, California, to Philadelphia, Pennsylvania. More than 3,000 citizens waited three hours to see the famous symbol of America's liberty. A special five-coach railroad train carried the bell on an open car surrounded by brass railings at the rear of the train. (Both DRC.)

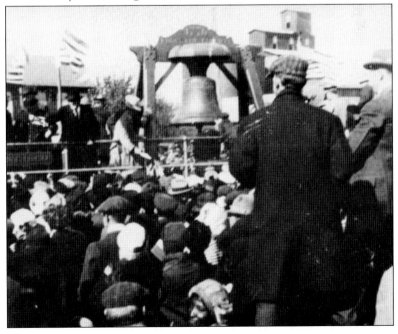

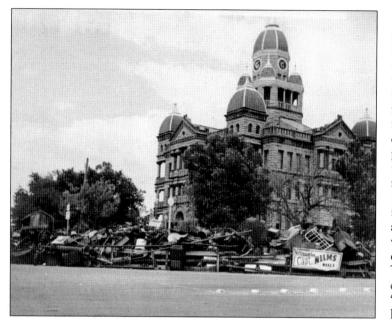

WORLD WAR II SCRAP METAL DRIVE. As part of the war effort, all citizens were asked to gather their scrap metal for the cause. The metal was melted down at processing plants to be recycled into military materials. A total of 150,000 pounds of iron, copper, brass, aluminum, and lead were stacked on the courthouse lawn. The scrap drive created a virtual "junkyard" on the lawn. (DRC.)

LIAISON TRAINING DETACHMENT GRADUATION. Thirty-eight student officers, shown here on the North Texas Teachers College campus, of Class L-19 of the First Army Air Forces Liaison Training Detachment were presented the silver wings of liaison pilots on June 3, 1943. Liaison pilots were enlisted pilots who flew light single-engine aircraft. They sometimes flew hazardous missions such as air observers for fighters, medical evacuations, intelligence missions, and delivery of war supplies. (DPL.)

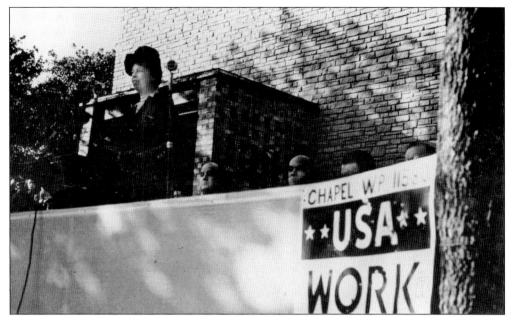

ELEANOR ROOSEVELT VISIT TO TEXAS STATE COLLEGE FOR WOMEN. Eleanor Roosevelt spoke at the dedication ceremonies for the Little Chapel-in-the-Woods on November 1, 1939, at the Texas State College for Women. She extolled the chapel by saying, "The work has been done well and anything done well and done with affection is beautiful." Mrs. Roosevelt spoke again that evening on life in the White House. (TWU.)

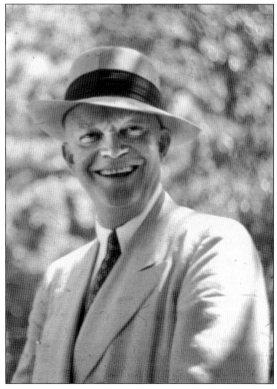

DWIGHT DAVID EISENHOWER SPEECH AT THE COURTHOUSE. Gen. Dwight D. Eisenhower visited Denton on June 20, 1952, in an effort to gain support in Texas for his battle with Sen. Robert A. Taft for the Republican presidential nomination. He encouraged an estimated crowd of 15,000 to participate in the "day by day service each of you can give—the practice of citizenship. It is a priceless privilege, and one that can slip from our grasp." (DCM.)

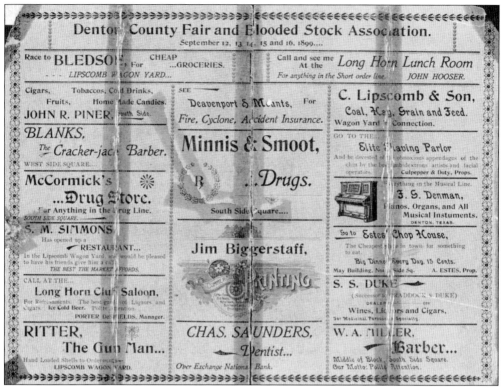

DENTON COUNTY FAIR. The Denton County Blooded Stock and Fair Association was organized on May 16, 1895, to host an annual fair and horse race at Avenue A and Hickory Street near North Texas Normal College. The horse track was located on West Chestnut Street. The fair was discontinued in 1903, and the property was sold to pay off debts. This is the race program printed for the 1899 fair and horse race. (Both DPL.)

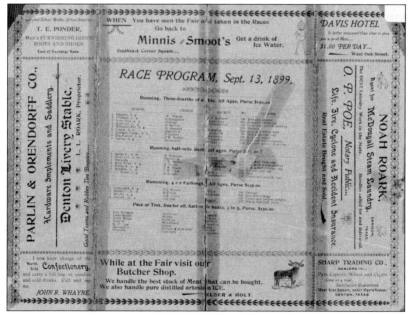

NORTH TEXAS STATE FAIR.
Interest in the Denton
County Fair was renewed in
the 1920s. The first fairs were
held in the city park and on
the athletic grounds at the
North Texas State Teachers
College. The Denton County
Fair Association was officially
inaugurated in 1928. The
fairgrounds moved to 13 acres
at the intersection of East
Hickory and Exposition Streets
in 1930. The fair operated
until 1942 when it closed for
the war and resumed briefly in
1946. In May 1948, Dr. W. C.
Kimbrough donated 22 acres
for a permanent fairgrounds
located northwest of the city
on U.S. Highway 24 (now
University Drive). In 1958,
the county fair took on a
new name—the North Texas
State Fair. Two activities still
popular at the fair include the
nightly rodeo and the youth
stock show. (Both DRC.)

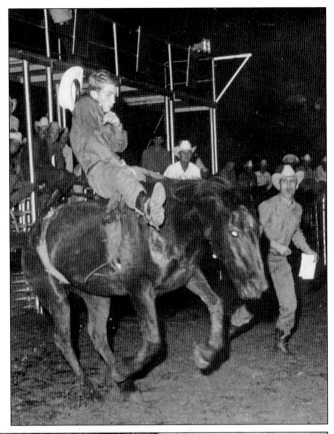

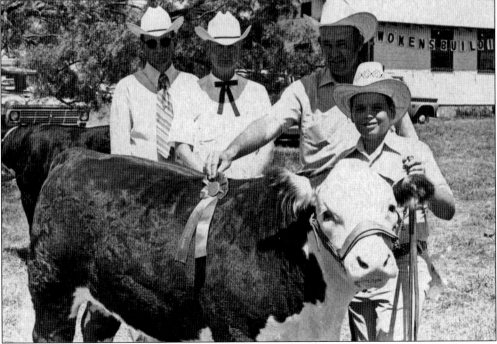

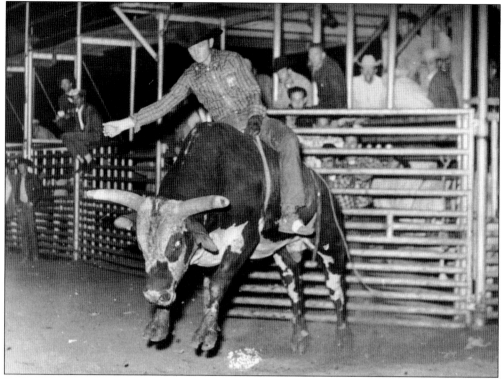

DENTON RODEO ASSOCIATION. The Denton Rodeo Association sponsored its first rodeo in June 1950 at the Denton County Fairgrounds. Rodeos were held in the early years every Friday and Saturday night in the summer. Later they ran only on Saturday nights. Earl Foreman, Doc Pitner, Claude Castleberry, Mark Hannah, Jack Skiles, and Lyle Montgomery were the board of the rodeo association. Events included bareback, bull dogging, barrel racing, cutting horse, calf roping, bull riding, and saddle bronc. The photograph above is of James Pugh and the one below is of Monroe Pugh. (Both DCM.)

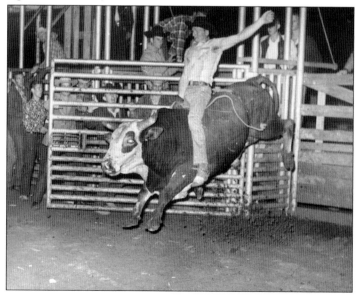

BONNIE AND CLYDE MOVIE PREMIERE. The southwestern premiere of the movie *Bonnie and Clyde*, starring Warren Beatty and Faye Dunaway, occurred at the Campus Theatre on September 13, 1967. Pictured here from left to right are Estelle Parsons, Warren Beatty, Bill Jones, Michael J. Pollard, and Annie Pollard at a seminar at the Holiday Inn-Denton. (DRC.)

BENJI MOVIE. Joe Camp, founder of Dallas studio Mulberry Square Productions, wrote the first *Benji* picture in 1968, but it was not completed and premiered until 1974. The movie was filmed on location in Denton at the Courthouse-on-the-Square and city hall. The first film earned $45 million worldwide and bred movie sequels and a television program. (DRC.)

SPRING FLING. The first Spring Fling festival was held on April 20, 1980, at the North Texas State Fairgrounds to support the arts. This event attracted an estimated 30,000 visitors. The city parks and recreation department sponsored the first JazzFest in October 1985. In 1991, these two events became the Denton Arts and Jazz Festival, hosting more than 300,000 visitors annually. (DRC.)

HOLIDAY LIGHTS ON THE SQUARE. The tradition of lighting the square for the Christmas holidays goes back to this photograph in the 1950s. Since 1988, the Holiday Lighting Festival has been held on the square to raise funds to purchase holiday banners, festival lights, and decorations. The event features music by Brave Combo and the Denton Community Band, which have been a part of the celebration since its inception. (DRC.)

DENTON CENTENNIAL, 1957. The Denton centennial was held April 22–24, 1957, and celebrated the 100th anniversary of the founding of Denton. Organizations, including churches, governmental offices, civic groups, and schools, joined the "Brothers of the Brush" or the "Centennial Belles." The Brothers agreed to grow facial hair and wear appropriate apparel. The "Vigilantes" gang represented county law enforcement. Featured in the above image are, from left to right, (front row) Sheriff Wiley H. Barnes, Chief Deputy Bud Gentle, and deputies W. E. Tipton, Jack Shepherd, and Buster Gibbs; (back row) deputy and jailer W. A. Kelly, FBI Agent Al Neely, and Deputy Olen Jones. The Belles agreed to participate in booster activities and wear costumes during the celebration days. The photograph below of the "Courthouse Belles," women who worked in the courthouse, was taken on the courthouse steps on April 18, 1957. (Both DCM.)

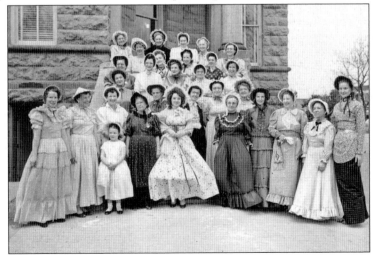

CENTENNIAL CHILDREN. Children played an important role in the centennial celebration. Twenty-five pioneer-clad Dentonites toured Dallas, including Mrs. Fred Vanderhoff (left), her granddaughter Sheila Vanderhoff (center), and Gertrude Longcope (right). (DRC.)

MASCOT. Ann Russell, daughter of William Norris Russell, dressed in her centennial finery, was the mascot of the Russell'N Belles. (DPL.)

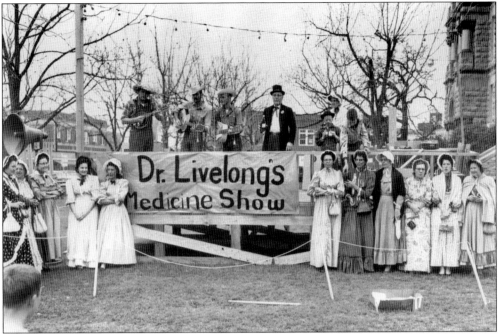

CENTENNIAL EVENTS. Events were held every day at the high school stadium and on the courthouse lawn. *Centurama*, a historical perspective commemorating the founding of the city and county, was staged throughout the event with many of Denton's citizens playing various roles. The photograph above is of one of the entertainment shows performed during the celebration. Dr. Livelong's Medicine Show was based on the traveling medicine peddlers who came into town selling patent medicine. Offenders of centennial regulations, not wearing proper attire such as centennial hats, ties, beards, and costumes, were placed in the mock jail seen below. A fine of 5¢ was imposed before the prisoner was released. The jailers pictured are, from left to right, Jack Shepherd, Martin Cole, Bud Gentle, and Kangaroo Court Judge Harry Owens. (Above, DPL; below, DRC.)

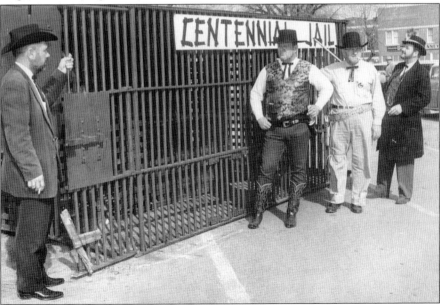

PARADE AROUND THE SQUARE. Students from the Texas State College for Women built a float depicting the Little Chapel-in-the-Woods (above). Rodeo performer Madeline Murphree (below) and the Town and Country Round-up Club participated in the parade around the courthouse square. (Both DCM.)

Patsy Pitner, Centennial Queen. Denton Centennial Queen Patsy Pitner (center) was crowned Queen of the centennial on April 22, 1957, by Gov. Price Daniel. Patsy and her pages, Jimmy Marbin (off camera) and Cheryl Orr (right) led the parade. (DCM.)

www.arcadiapublishing.com

Discover books about the town where you grew up, the cities where your friends and families live, the town where your parents met, or even that retirement spot you've been dreaming about. Our Web site provides history lovers with exclusive deals, advanced notification about new titles, e-mail alerts of author events, and much more.

MADE IN THE USA

Arcadia Publishing, the leading local history publisher in the United States, is committed to making history accessible and meaningful through publishing books that celebrate and preserve the heritage of America's people and places. Consistent with our mission to preserve history on a local level, this book was printed in South Carolina on American-made paper and manufactured entirely in the United States.

This book carries the accredited Forest Stewardship Council (FSC) label and is printed on 100 percent FSC-certified paper. Products carrying the FSC label are independently certified to assure consumers that they come from forests that are managed to meet the social, economic, and ecological needs of present and future generations.

FSC
Mixed Sources
Product group from well-managed
forests and other controlled sources

Cert no. SW-COC-001530
www.fsc.org
© 1996 Forest Stewardship Council

Find Your Place in History.